PAST & PRESENT

ANNAPOLIS

OPPOSITE: This 1904 Tuck postcard view of Annapolis from the State House dome looks toward Annapolis harbor and across the bridge to Eastport when Annapolis had a population under 8,000. While the Annapolis High School and St. Mary's Church still stand, the large building in the center was the Colonial Theatre, which burned in 1919. It had opened in 1901 in the City Hotel, previously called Mann's Tavern, where George Washington stayed. Much of that area today is covered by stores on Main Street and the Hillman Parking Garage. (Author's collection.)

PAST PRESENT

ANNAPOLIS

John L. Conley

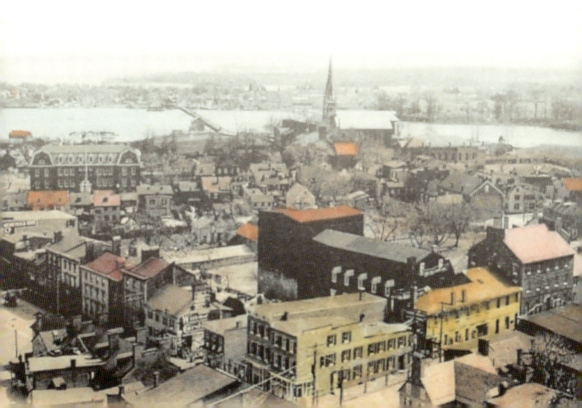

This book is dedicated to all those volunteers who help to research, preserve, and share local history and to history teachers everywhere.

Copyright © 2024 by John L. Conley
ISBN 978-1-4671-6188-6

Library of Congress Control Number: 2024936637

Published by Arcadia Publishing
Charleston, South Carolina

Printed in the United States of America

For all general information, please contact Arcadia Publishing:
Telephone 843-853-2070
Fax 843-853-0044
E-mail sales@arcadiapublishing.com

Visit us on the Internet at www.arcadiapublishing.com

ON THE FRONT COVER: The intersection of Francis and Main Streets, shown in 1891, was the location of the Annapolis Market in the mid-1730s. In the late 1800s, Louis H. Rehn operated a dry goods and clothing store in the building on the triangle where the streets meet. The top floor was eventually expanded, and the location has housed many businesses since the 1890s, including grocery stores, restaurants, banks for over 40 years, and retail shops as it does today. In 1981, it was named the Michaelson Building in honor of Benjamin Michaelson Sr., founder of the Annapolis Federal Savings Bank. Renovations to the building at 120 Main Street included the removal of the doors that opened onto Francis Street. (Past image, courtesy the George Forbes Collection of the Maryland State Archives; present image, photograph by author.)

ON THE BACK COVER: While the styles of clothing and modes of transportation have changed since the Annapolis Market Space was established at the City Dock in 1786, many of the buildings shown on this early-1900s postcard still exist today. Well into the 1970s, the area had groceries, drugstores, and other businesses catering to residents and the commercial boating industries, but today, restaurants and retail shops serve tourists and recreational boaters, as well as local citizens. Thanks to the efforts of Historic Annapolis Inc. and others, repeated efforts over the years to "modernize" the historical presence of the Market Space have been unsuccessful. (Past image, author's collection.)

Contents

Acknowledgments		vii
Introduction		ix
1.	State Circle	11
2.	Church Circle	21
3.	Historic Buildings	29
4.	Harbor and Market House	51
5.	A Walk about Town	63
6.	St. John's College	77
7.	US Naval Academy	85

Acknowledgments

I called upon many people while writing this book. Most are authors whose books I highly recommend to readers seeking to learn more about Annapolis. Jane McWilliams's book *Annapolis City on the Severn* will be a valuable resource well into the future. Capt. Randall Bannister's (USN retired) book *The U.S. Naval Academy in Postcards, 1900–1930* was a template for my "history through postcards" approach. Dr. Robert Worden wrote *Saint Mary's Church in Annapolis, Maryland: A Sesquicentennial History 1853–2003* and leads the Annapolis History Consortium. The historic photograph books of Marion Warren and Mame Warren, including *Then Again . . . Annapolis 1900–1965*, are classics. Col. Charles Emery's 1949 book *Photogenic Annapolis* shows the settings he used and is instructional. Annapolis city dock history is documented in Ginger Doyle's book *Gone to Market: The Annapolis Market House, 1698–2005*. An essential resource is *Architecture in Annapolis A Field Guide* by Marcia M. Miller and Orlando Ridout V. Michael P. Parker's *Presidents Hill: Building an Annapolis Neighborhood 1664–2005* is a detailed history of the West Street corridor. In this social media information age, thank you to Sue Steinbrook, whose Facebook page *Historic Houses of Annapolis* provides an ongoing discussion of Annapolis properties. She is writing a book on the subject. Likewise, Dale Darden's *Friends of Annapolis* Facebook page is a reliable source for historical Annapolis information. I want to acknowledge the postcard photographers and publishers whose work from the early 20th century continues to keep history alive. Gratitude also to the shops that made them available, like the George W. Jones Stationery Store on Main Street, where many of the early-1900s postcards in this book were sold. The color postcards in this book were originally black and white photographs that were later colorized in photography labs. Groups like Historic Annapolis, founded by Anne St. Claire Wright, and the Maryland State Archives have worked to research and share Annapolis's history and to protect and preserve historic buildings. Hanna Wall is a former Annapolis tour guide who provided useful insight. Finally, I would like to thank my wife, Darlene Conley, for frequently asking, "Shouldn't you be working on your book?"

Unless otherwise noted, all past images are from the author's collection, and all present photographs were taken by the author.

Introduction

America should rejoice that it is so, for thus, has Annapolis been preserved as our country's most truly colonial city. You may wander about this fine old community and feel that you are living in those dramatic days when the little city on the Severn had a major part in shaping the course of the Nation's history.

—Gilbert Grosvenor, President
National Geographic Society, 1927

A visitor today to Maryland's capital city could just as well make that observation. Annapolis was itself declared a national historic landmark in 1965.

To the residents of Maryland, Annapolis has been the state's capital since 1694, with a magnificent State House that has been in continuous use longer than any other in the United States. To the nation, it is famous as the home of the US Naval Academy (USNA) since 1845. To the seafaring world, its busy harbor is now known more for its pleasure boats, luxury yacht shows, and sailing races than as the busy commercial port it once was.

More than any other colonial city, Annapolis has been and remains a working history city where buildings constructed in the 18th and 19th centuries are still used for residences, commerce, religious observance, and education. Unlike the impressive but carefully restored neighbor to its south, Williamsburg, Annapolis is a living museum with a history that continues to evolve rather than being frozen in time.

There have been many scholarly books written on the history of Annapolis, and others have celebrated classic photographs from back to the 1800s. This book employs a different approach to show, literally, the past and present of this endearing and enduring city on Chesapeake Bay. The book uses antique postcards, most of which were mailed over 100 years ago but which in one image can still share thousands of words of history. Current photographs show the postcard senders what they would see if they could return to Annapolis today, and past postcards show today's readers what they would have seen when the cards with 1¢ stamps were posted.

For a small city, Annapolis generated many postcards that are now sought by collectors. A primary reason for that was the US Naval Academy, which has attracted thousands of Midshipmen students and visitors from every state in the country. What better way to describe to "the folks back home" in Oregon or Indiana where a midshipman or instructor lived and studied or the buildings and scenes where they enjoyed a brief escape from "the Yard" than through a postcard? Likewise, the home of the state government and busy harbor have long attracted visitors.

The Province of Maryland was established in 1632 with the first governing body in St. Mary's City. In 1694, Gov. Francis Nicholson moved the colony's capital to Ann Arundell Town, near an area sailed past by John Smith in 1608 and longtime home to members of the Piscataway, Susquehannock, and other Indigenous tribes. He named it Annapolis in honor of Princess Anne, who became Queen of England in 1708.

Nicholson is a key figure in Annapolis history even today, as he adopted the baroque approach found in Europe to design the layout of the new capital—radiating streets from important

circles. The State House was built on the Stadt Circle, the highest point in the new town. For the spiritual needs of the new capital and in recognition of the importance of the Church of England, he established Church Circle, where the third St. Anne's Church stands today. Most major streets in downtown Annapolis still transit those circles.

The impact of England on early Annapolis cannot be overstated. Annapolis is in Anne Arundel County, named for Lady Anne Arundell, wife of Cecilius Calvert, 2nd Lord Baltimore and founder of the Maryland colony. It is in Maryland, named after Queen Henrietta Maria, wife of King Charles I, who signed the 1632 charter establishing the Maryland colony.

Many of the massive brick homes of early Annapolis aristocracy reflected English architecture and are located on streets named Duke of Gloucester, Fleet, King George, and Prince George. The city is on the Severn River, named after the British river separating England and Wales. While visitors to Annapolis can still see the homes connected to four signers of the Declaration of Independence, the separation from the Mother Country was not without controversy. Several Loyalists returned to England or moved to Canada. However, Queen Elizabeth was warmly accepted in Annapolis in 1954.

Annapolis is blessed with two institutions of higher education, both of which enhance the local community. St. John's College traces its roots to King William's School, founded in 1696, and the US Naval Academy was established in 1845. The curricula of the two schools could not be more diametrically opposed, though they do meet annually for bragging rights in a "Midshipmen versus Johnnies" Annapolis Cup Croquet Match on the St. John's campus.

Annapolis has been called the Athens of America, and there is no place that Plato or Socrates would be more comfortable today than at St. John's College. It offers a liberal arts degree in the Great Books Program, where students explore over 200 revolutionary books from over 3,000 years, and is centered on the study of the liberal arts through intense reading and seminar-style discussion classes.

At the other end of the spectrum, the Naval Academy offers only a bachelor's degree in science. Although other majors have been allowed since 1968, the academic program is focused on science, technology, engineering, and mathematics to meet the current and future highly technical needs of the Navy. At least two-thirds of a graduating class must be from those areas. Students have access to the latest technology and gain applied fleet experience during summer cruises and assignments.

Of course, there have been many changes to Annapolis over the years. The boundaries of the historic city were significantly increased in 1951–1952 to include areas from Parole to West Annapolis to Eastport. The city population more than doubled to 23,385 between 1950 and 1960.

The stores and businesses that lined the streets to meet the daily needs of residents for food, clothing, medicine, and housewares have been replaced by offices, restaurants, high-end specialty stores, and tourist shops. Traditional stores have moved to shopping centers away from the central part of town. There are no more Sears or A&Ps downtown. While there once were three movie theaters just blocks from Church Circle, now there are none. Highways have replaced the trains and buses that once regularly connected Annapolis to Washington and Baltimore.

There is little affordable housing in Annapolis, and areas where low- or medium-income people can afford to live have been reduced. The median household income was $97,219 in 2022; the median home sales price in 2023 was $488,000. The construction of high-rise condominiums within and on the outskirts of the city has increased.

Annapolis remains an attractive place to live or visit. Postcards mailed today are among the last uses of handwritten communications. One from Annapolis would still say, "Wish you were here."

CHAPTER 1

STATE CIRCLE

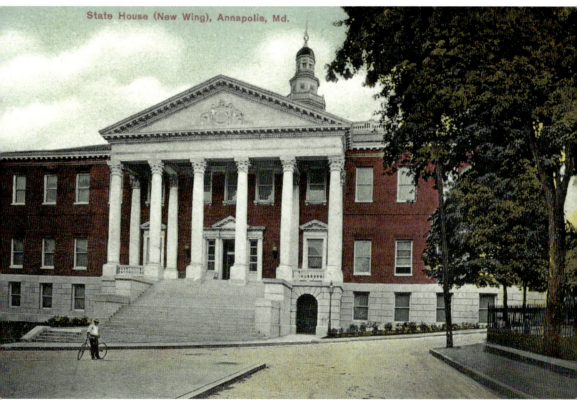

Originally known as Publick Circle in Gov. Francis Nicholson's 1695 plan, today's State Circle is the center of Maryland state government. Growth in government resulted in the construction of a new State House annex, which opened in 1906 and replaced two earlier annexes. New buildings were constructed on State Circle to house the State Library and State Court of Appeals, which were removed from the original building. The annex is the main entrance to the State House.

11

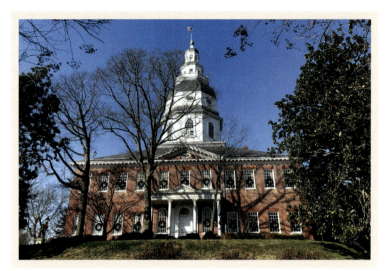

Completed in 1779, Maryland's State House replaced earlier ones built in 1707 and 1769. It is the longest in continuous service in the United States. The iconic wooden dome was added in 1788. It is 181 feet to the top of the weather vane. Annapolis briefly served as the nation's capital when the Continental Congress met there from 1783 to 1784. The statue of Supreme Court justice Roger Taney, author of the Dred Scott Decision, was removed in 2017.

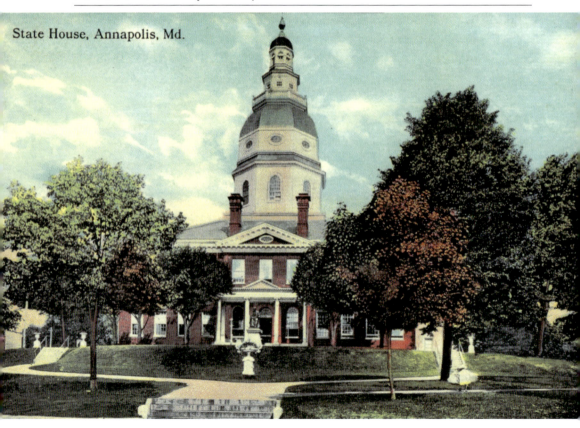

State House, Annapolis, Md.

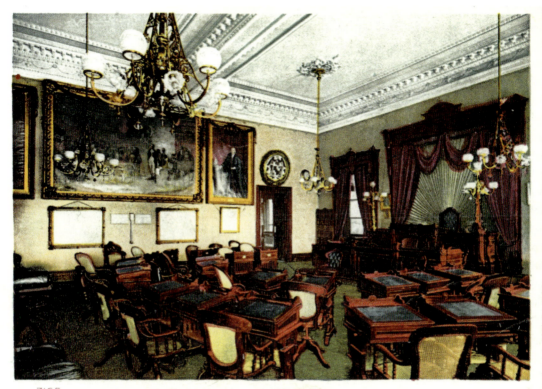

7165 SENATE CHAMBER. STATE CAPITOL. ANNAPOLIS. MD

The Old Senate Chamber, seen here in 1903, is restored to the way it looked when Congress met there in 1783–1784, when Gen. George Washington resigned his commission as commander in chief of the Continental Army and when the Treaty of Paris was ratified ending the Revolutionary War. An original copy of Washington's speech is displayed in the Rotunda. A ceremony is held in the chamber every President's Day. The 1903 Senate had 15 Democrats and 11 Republicans.

STATE CIRCLE

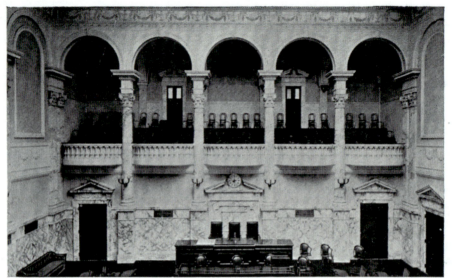

Gottlieb's Department Store. **INTERIOR OF THE HOUSE OF DELEGATES, FRONT VIEW, STATE CAPITOL.** Annapolis, Md.

The House of Delegates met in the new annex for the first time in 1904. Portraits of many past House speakers line House chamber walls, as do those of the four Maryland signers of the Declaration of Independence, William Paca, Thomas Stone, Samuel Chase, and Charles Carroll. The Plexiglas booths in the House and Senate chambers were added for the electronic press. Visitors can watch legislative deliberations from the balconies. The House has 141 members.

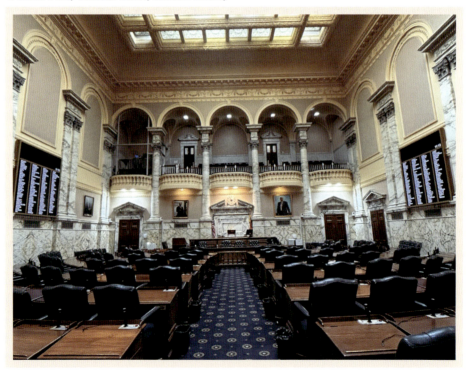

STATE CIRCLE

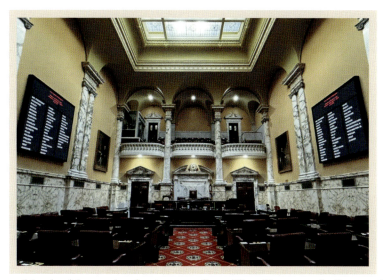

The current Maryland Senate chamber is part of the annex to the state capitol. The Senate meets for 90 days each year, beginning on the second Wednesday in January. The black and gold Italian marble and red and white rug are tributes to the colors of the Maryland flag. The House and Senate chambers have Tiffany skylights. Votes are cast and recorded electronically. The Senate has 47 members from the 23 Maryland counties and Baltimore City.

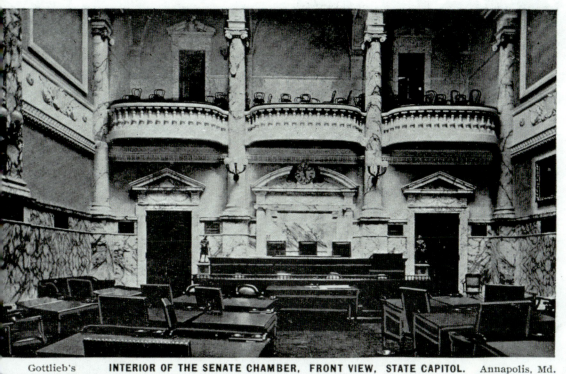

Gottlieb's Department Store. INTERIOR OF THE SENATE CHAMBER, FRONT VIEW, STATE CAPITOL. Annapolis, Md.

STATE CIRCLE

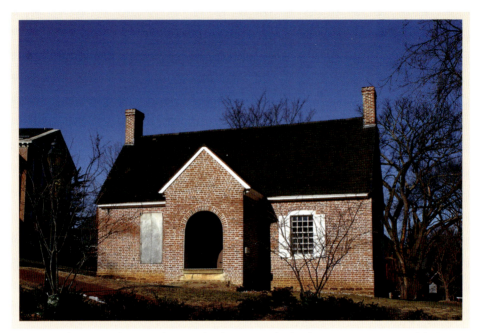

Constructed in 1735 by Patrick Creagh, the Old Treasury Building on the capitol grounds is the oldest public building in Annapolis. With thick walls and heavy doors, it served as Maryland's Treasury until 1901. It later became the headquarters of the Maryland State Board of Education, Anne Arundel County Superintendent of Schools, and Maryland Historic Trust. It is currently being renovated and will become a museum featuring ties to 17th-century Maryland.

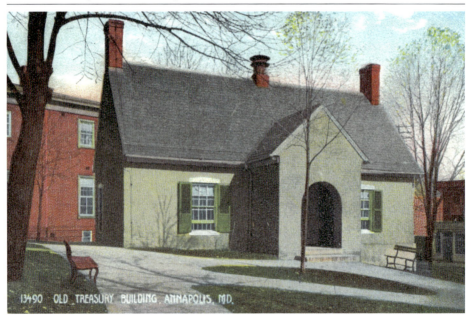

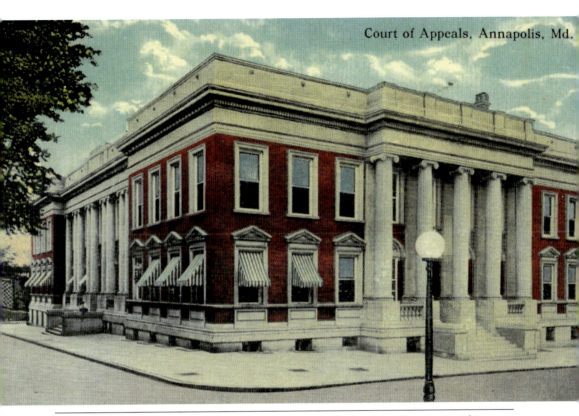

Court of Appeals, Annapolis, Md.

The Maryland Court of Appeals and Law Library building was constructed in 1904 after they were moved out of the State House. That building was replaced in 1974 by the Legislative Services Building, which will be replaced by a new building in 2025. It will retain Annapolis's Georgian architecture, complete with red brick. The statue honoring Baltimore native and first African American Supreme Court justice Thurgood Marshall was erected on Lawyer's Square in front of the building in 1996.

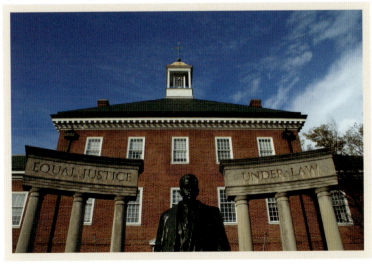

STATE CIRCLE

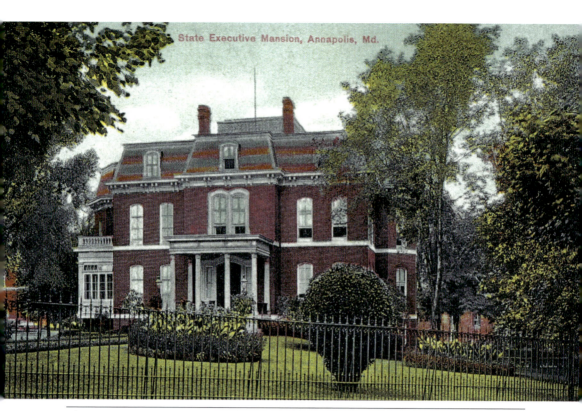

The cornerstone was laid in 1868 for the Victorian-style Governor's Mansion, also known as "Government House," the first permanent home for Maryland governors. With some opposition due to costs in 1935–1936, the aging structure was converted to today's five-part Georgian Colonial Revival style with two wings. The building houses many Maryland historical pieces, including paintings by Charles Wilson Peale. Visits can be arranged by appointment. The Government House Trust administers it.

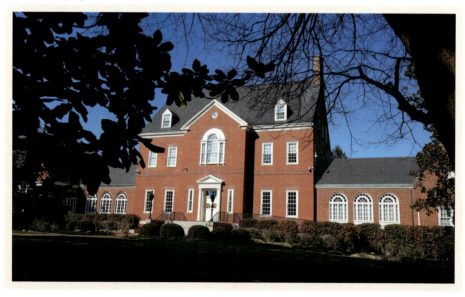

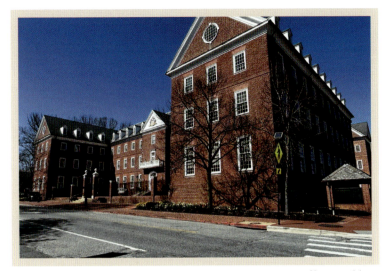

A new building for the Maryland State Comptroller and other agencies was constructed on State Circle in 1939 in the Georgian Colonial style after another site on the circle was rejected to save the Boardley-Randall House. It was renovated and named the James Senate Office Building in 1974. The offices for all Maryland state senators and Senate hearing rooms are in the building, and a multimillion-dollar addition was dedicated as the Miller Senate Building in 2001.

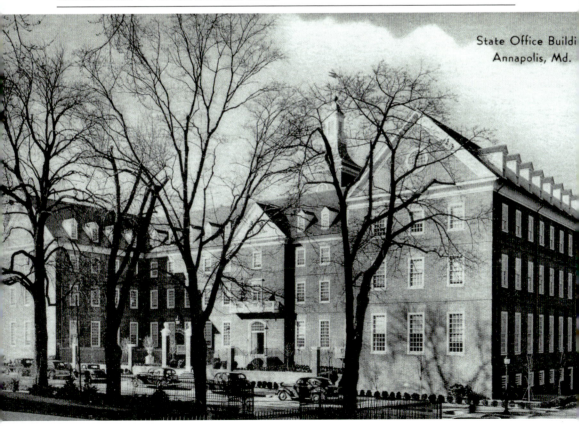

State Circle

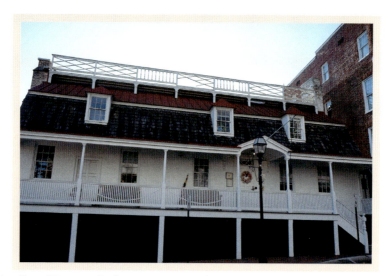

The John Shaw House is the longest-serving building on State Circle. Completed in 1725, the house also has an entry from Main Street. John Shaw was a cabinetmaker who made much of the furniture in the State House and worked on the capitol dome. He lived there from 1784 to 1829. The building has had many occupants over the years, including the Elks Club in 1900 and recently the state government. It was transferred to Historic Annapolis in 2021.

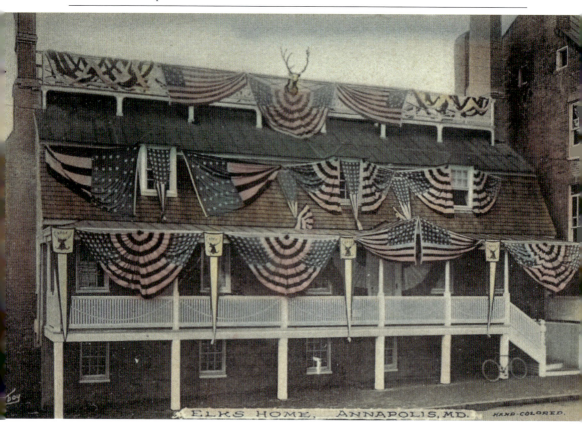

CHAPTER

Church Circle

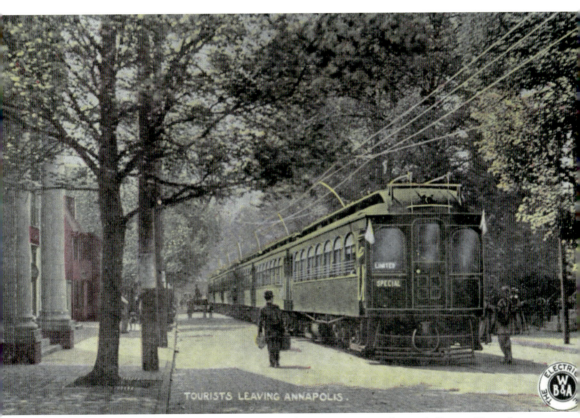

The main automotive entrance into Annapolis from the west of the city was via West Street into historic Church Circle, the site of St. Anne's Episcopalian Church. That changed when Rowe Boulevard was built between downtown Annapolis and Route 50 and opened in 1954. This six-passenger-car train operated from the Washington, Baltimore & Annapolis Electric Railroad (WB&A) station on West Street.

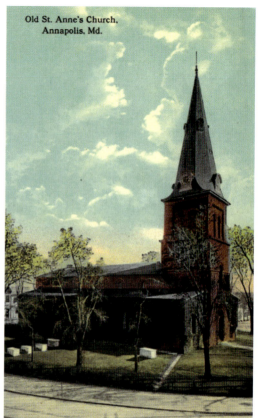

Constructed in 1858, the current St. Anne's Episcopal Church and its two predecessors have welcomed visitors to Church Circle since 1699. The body of the last English governor of Maryland, Sir Robert Eden, was moved here for burial in 1926. He died in Annapolis in 1784 after returning from England. Annapolis's first mayor, Amos Garrett, died in 1727 and is buried here. Church Circle was designed in accordance with Gov. Francis Nicholson's baroque plan for a circle with radiating streets.

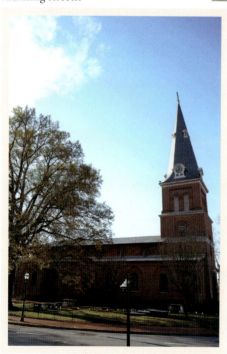

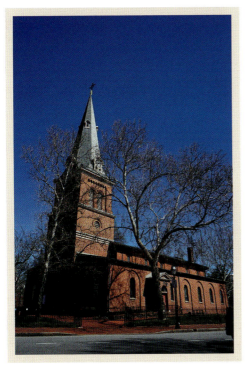

The first St. Anne's Church was constructed on the present grounds in 1699. The second church burned down in 1858, and the present church opened for services in 1859. It is shown here on an early-1870s *carte de visite* by Annapolis photographer Charles Hopkins. It includes a window designed and built by the Tiffany Glass and Decorating Company in about 1894. The steeple was completed by 1866, and the Annapolis town clocks were installed on all four sides.

Church Circle

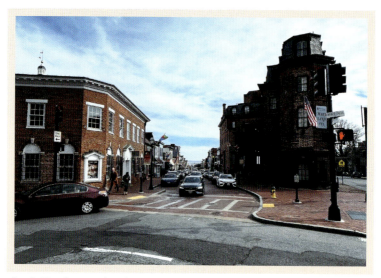

The Maryland Hotel, on Church Circle at the top of Main Street, was included in a 1794 watercolor painting along with the State House and St. Anne's Church. On this c. 1910 postcard, a WB&A trolley transits Main Street and seems to stop in front of the bakery. Note that the card was "hand-colored." All photographs from that era were black and white, and color was added in labs. The hotel today includes guest rooms, meeting rooms, and a pub.

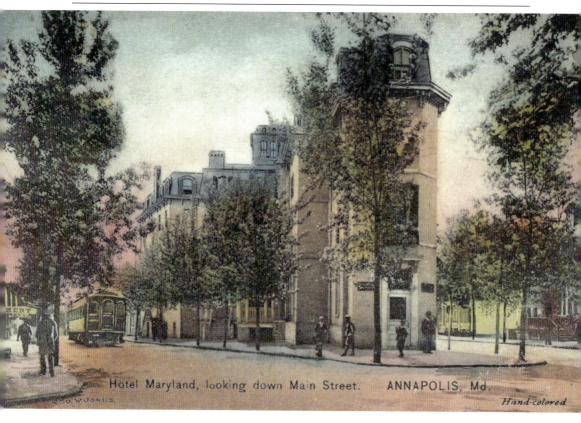

Church Circle

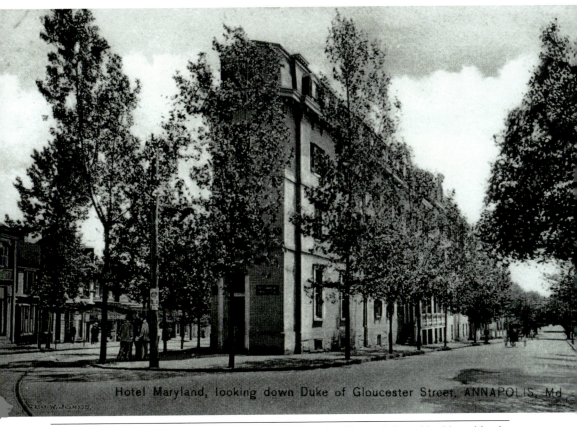

Hotel Maryland, looking down Duke of Gloucester Street, ANNAPOLIS, Md.

The Maryland Hotel has graced Church Circle on a lot purchased by Thomas Hyde in 1772. Distinguished travelers could enjoy a comfortable room for $3 in 1888. The hotel is today operated by Historic Hotels of America. The radiating street design resulted in many triangular "flatiron" shaped buildings like the hotel at Main and Duke of Gloucester Streets. Duke of Gloucester Street runs past many stylish buildings, including city hall and St. Mary's Church, to the bridge to Eastport.

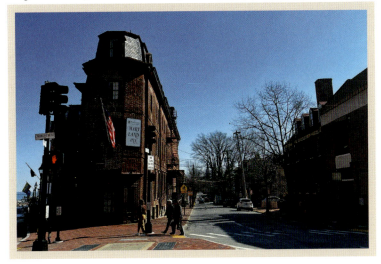

Church Circle

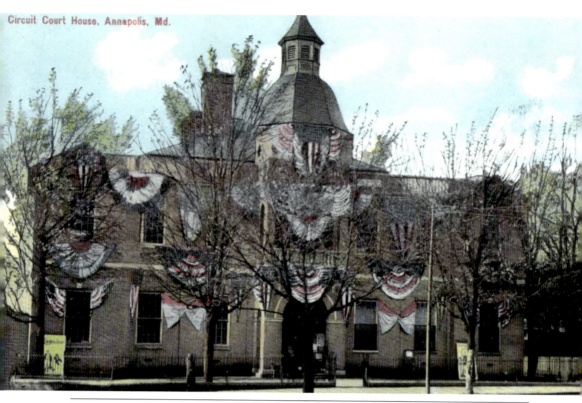

Annapolis also serves as the county seat of Anne Arundel County. Portions of the current courthouse were constructed in 1821, and the distinctive projecting pavilions, entrance tower, and cupola additions seen here were made in the early 1890s. A major expansion of the courthouse took place in the 1990s, but the historic building continues to serve as the entrance to the new courthouse.

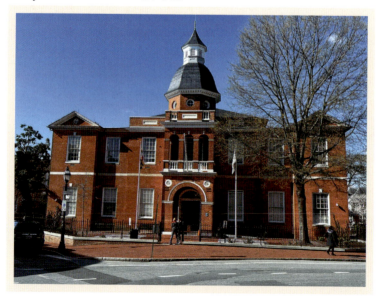

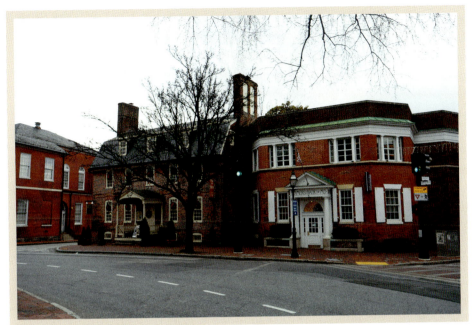

Farmers National Bank, founded in 1805, Reynolds Tavern, and other buildings have occupied Church Circle at West Street since 1747. The bank purchased the tavern in 1812 and added a rear wing in 1906. The Annapolis Public Library was in the Reynolds building from 1936 to 1974. The Public Library Association of Anne Arundel County donated the building to the National Historic Trust in 1974. It again hosts a restaurant and lodging. The bank building still carries the Farmers National Bank name and is operated by Truist.

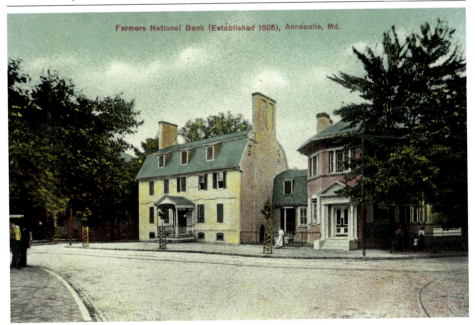

Church Circle

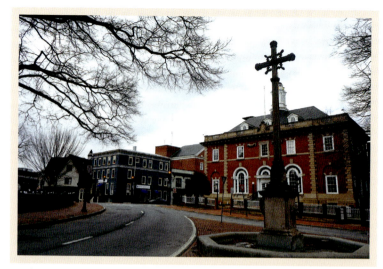

The Annapolis Post Office and Customs House opened in 1901 on College Avenue, which transits both State and Church Circles, and it served as the main post office until 2015. It was then completely renovated and now houses offices of the Maryland state government. The Southgate Fountain was dedicated in 1901 to honor Dr. William Scott Southgate, who was rector of St. Anne's from 1869 to 1899. The building at Northwest Street on the left is now a real estate office.

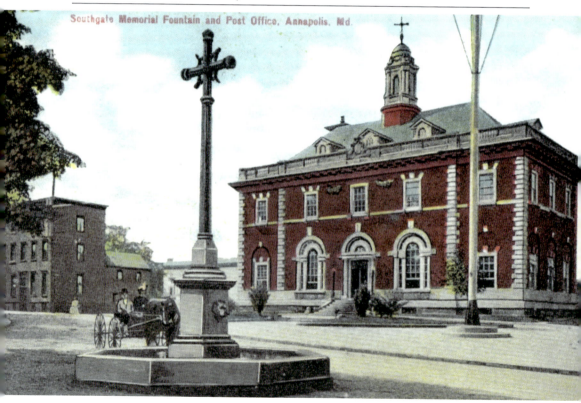

CHAPTER 3

HISTORIC BUILDINGS

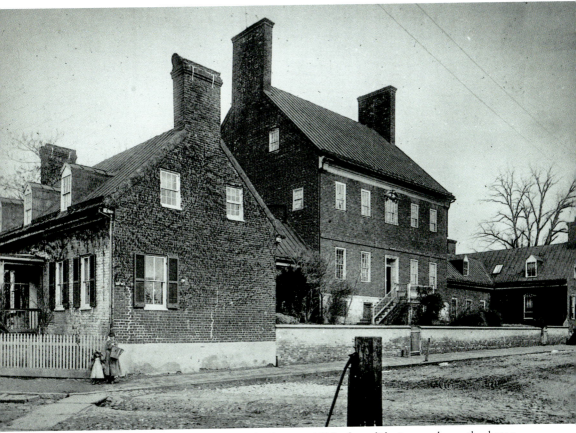

Likely nowhere else in the country, a brisk walk could take the visitor past homes connected to four signers of the Declaration of Independence in less than half an hour. This pre-1900 glass slide image shows the home of James Brice, not a signer, on East Street with a water pump and walkway across an unpaved road.

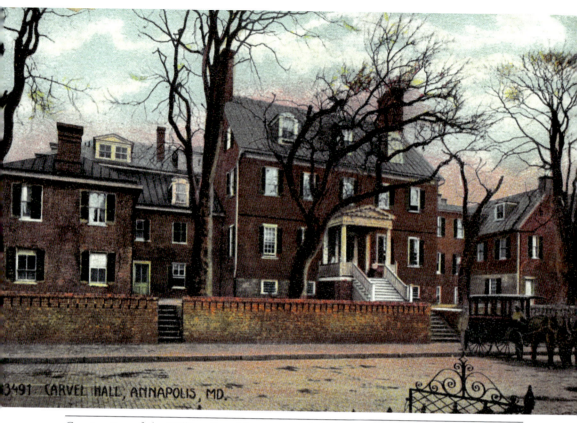

Construction of the William Paca House on Prince George Street began in 1763. Paca signed the Declaration of Independence while living there. In 1901, it became an entrance to the new Carvel Hall hotel, portions of which can be seen over the original building and which hosted visitors to the Naval Academy. Historic Annapolis Foundation helped save the historic structure when the hotel closed in 1965. It was named after the fictional character Richard Carvel. It is open for tours.

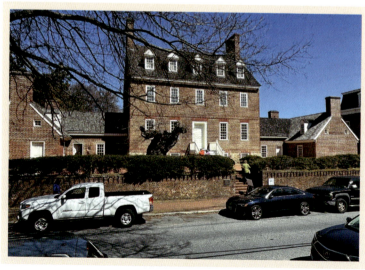

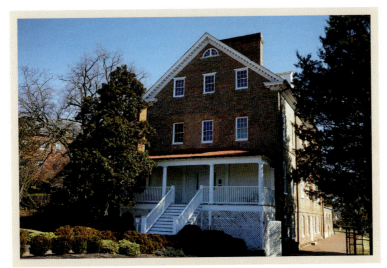

This 1906 postcard shows the birthplace of Charles Carroll of Carrollton (1737–1832) on the property the family occupied since the early 1700s and donated to the Redemptorist Order in 1852. The house was built in the 1720s and has had many alterations. He was the only Roman Catholic to sign the Declaration of Independence and was the last surviving signer. It has served as a private home, novitiate, and rectory. Current uses include offices, a museum, and special events.

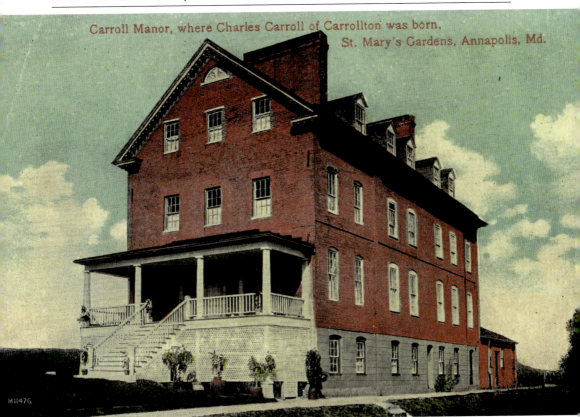

HISTORIC BUILDINGS

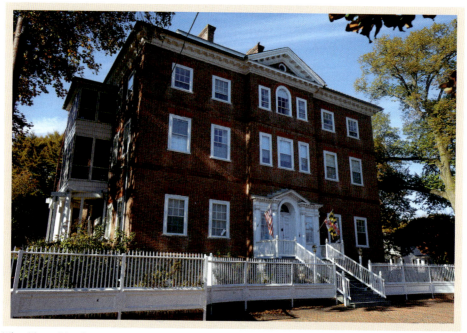

The Chase-Lloyd House on Maryland Avenue is the only three-story house from the colonial period. Declaration of Independence signer Samuel Chase began construction of the house in 1769 and later sold it to Edward Lloyd, who finished construction. The house was left to be used as a home for aged women by Hester Chase Rideout in 1868. That service ended in 2024, and future use of the property will be decided by the Episcopal Diocese of Maryland.

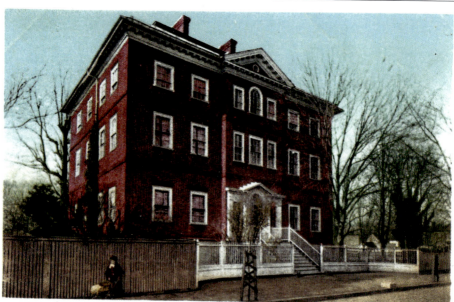

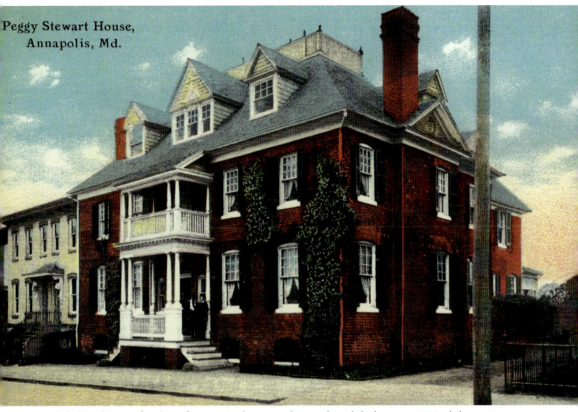

While best known for the infamous Anthony Stewart, the unfortunate tea taxpayer who had to burn his ship the *Peggy Stewart* in Annapolis Harbor in 1779, the Peggy Stewart House was home to another Maryland signer of the Declaration of Independence, Thomas Stone, who purchased the home in 1783 while serving in the Maryland State Senate. The home was built in the early 1760s on Hanover Street and today looks over the Naval Academy wall at the USNA Chapel and grounds.

HISTORIC BUILDINGS

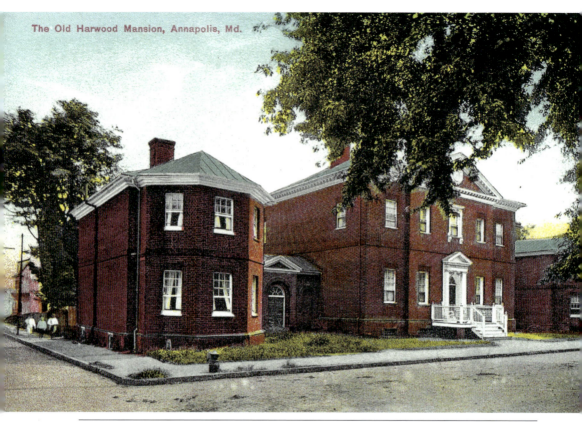

William Buckland designed the Hammond-Harwood House on Maryland Avenue, which was commissioned in 1774 by Mathias Hammond. The Harwoods were the last private family to occupy the house, purchased by St. John's College in 1926. Thanks to the Federated Garden Clubs of Maryland and the Hammond-Harwood House Association in the 1930s, it was purchased from St. John's and saved. It is a museum of 18th-century architecture and art featuring paintings by Charles Wilson Peale and furniture by John Shaw.

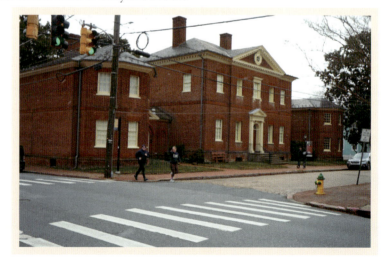

HISTORIC BUILDINGS

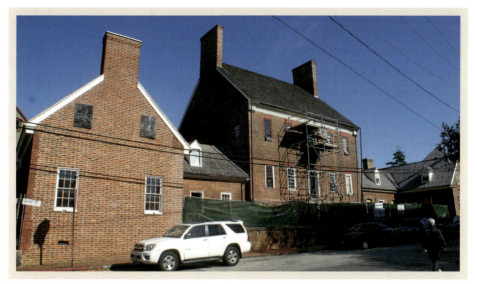

The James Brice House is a five-part Georgian-style house on East Street. The ivy-covered wing served as a carriage house. The house is 155 feet wide with chimneys 90 feet high. Brice was mayor of Annapolis and interim governor of Maryland in 1792. It has been owned by various private families and St. John's College, and it was the headquarters of the International Masonry Institute. Historic Annapolis is restoring the house to its 1774 appearance, and it will be a museum and education center.

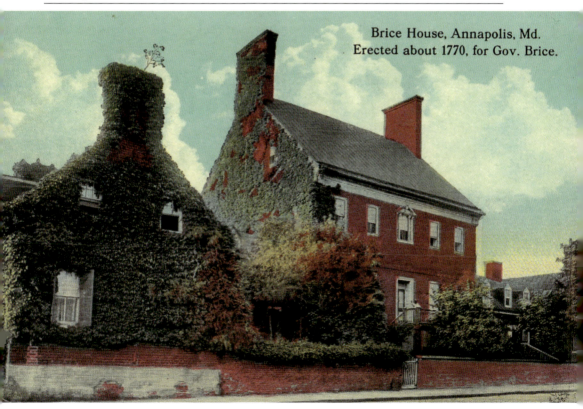

HISTORIC BUILDINGS

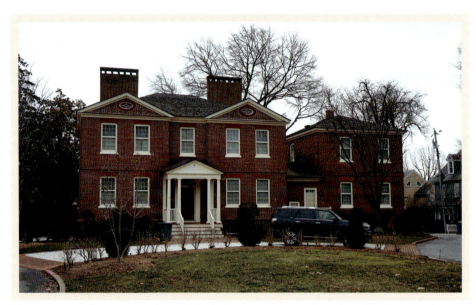

The Murray residence at Acton's Creek (today's Spa Creek) was constructed facing where the original city docks were located in the early 1770s. It is sometimes referred to as Acton Hall and today is a private residence. The wing portion on the right of this c. 1905 postcard was removed and replaced around 1910. Annapolis lawyer James Murray purchased the property in 1837. His heirs sold portions of the property upon which many attractive houses of today's Murray Hill are located.

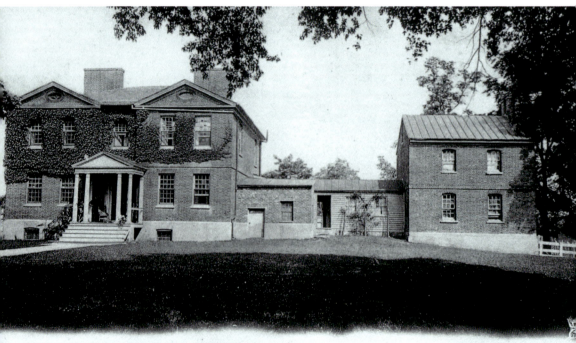

ANNAPOLIS, MD. THE MURRAY RESIDENCE AT ACTON. George W. Jones, Annapolis, Md.

Historic Buildings

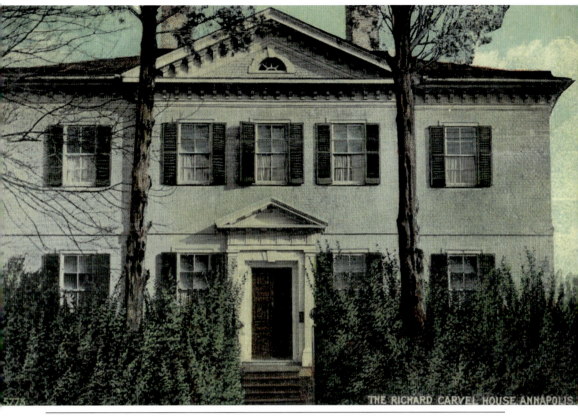

Dr. Upton Scott built this home on Shipwright Street in the 1760s. Robert Eden, the last proprietary governor of Maryland, died in this house in 1784. Francis Scott Key lived there while at St. John's College. The Sisters of Notre Dame acquired the house in 1872 and lived there until 1968. The house was the basis of the home of fictional character Richard Carvel in the book of the same name written in 1899. The home is now privately owned.

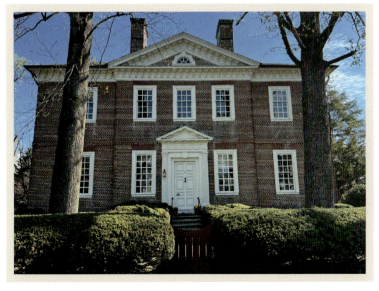

HISTORIC BUILDINGS

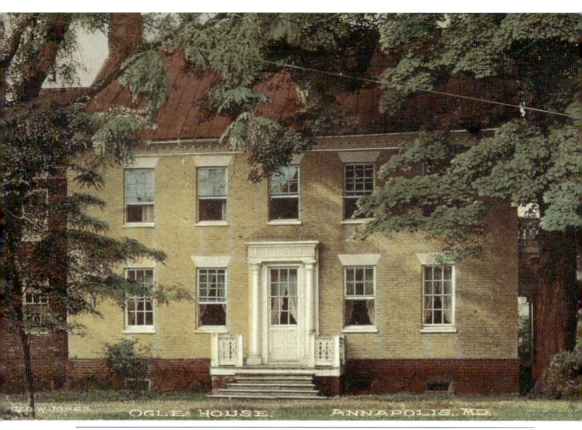

Dr. William Stephenson began building this house in 1739. It became the home of Gov. Samuel Ogle in 1747. An avid horseman, Ogle is credited with bringing horse racing to the colonies. His son Benjamin bought the house in 1773 and became governor in 1798. George Washington dined there in 1775, and it hosted the Marquis de Lafayette in 1845. It became the US Naval Academy Alumni Association headquarters in 1945. The association sold it to an investment group in 2023.

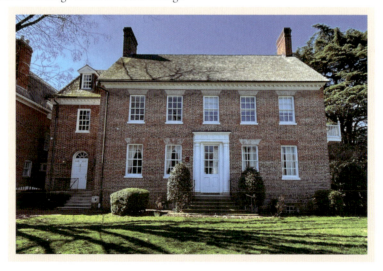

HISTORIC BUILDINGS

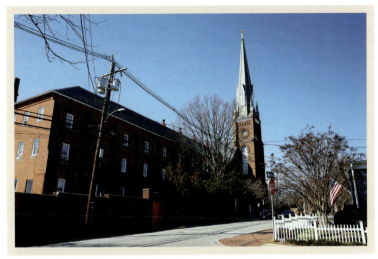

Bishop John Neumann, who was canonized a saint in 1977, laid the cornerstone for the church on Duke of Gloucester Street in 1858. The church and attached college were completed in 1860. Redemptorist priests from St. Mary's ministered to Union wounded soldiers and former prisoners during the Civil War. The first nuns to teach schoolchildren were the School Sisters of Notre Dame, who arrived in 1867. They also instructed Black students. The college building today is used as a rectory.

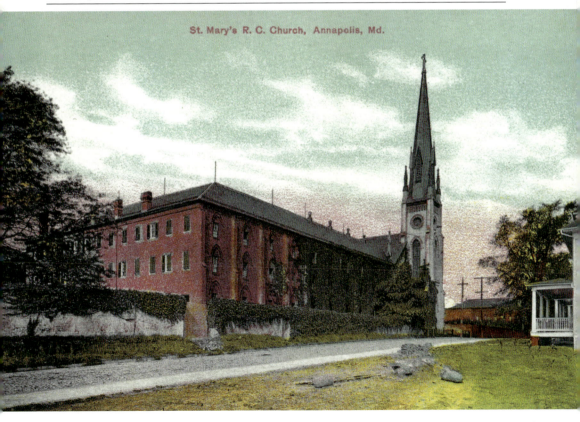

HISTORIC BUILDINGS

This postcard, mailed in 1909, shows the residence of James M. Munroe, a house that traces its roots to 1860 and was previously known as Tuck House and Eldon. Munroe served as mayor of Annapolis from 1871 to 1875. The house was demolished in 1922, and an advertisement that year listed "brick, marble, mantels, latrobe, stove and furnace" taken from it. Materials from it were used to construct houses on today's Munroe Court, which connects to West Street near Church Circle.

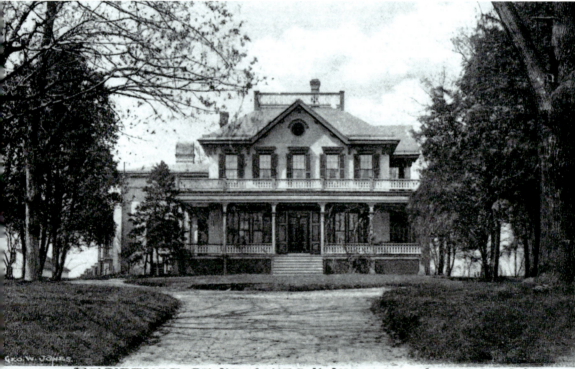

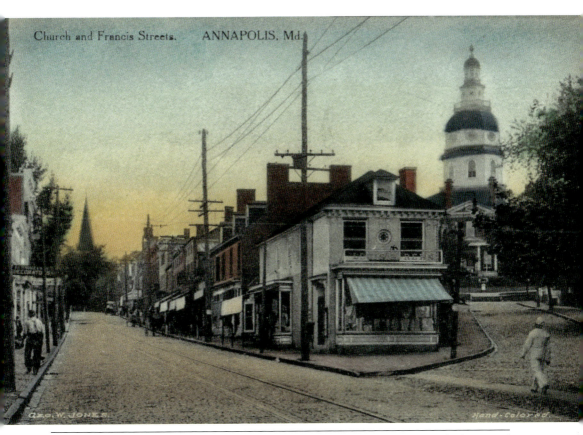

Since the 1800s, the triangle formed where Francis Street from State Circle and Church Street, today's Main Street, from Church Circle meet is the key intersection for commerce and pleasure in the historic district. Francis Street is named for Francis Nicholson, the royal governor of Maryland who moved the capital to Annapolis and is responsible for the plan featuring two circles and radiating streets still found today. The tracks for trolley service from 1908 to 1935 are long gone.

HISTORIC BUILDINGS

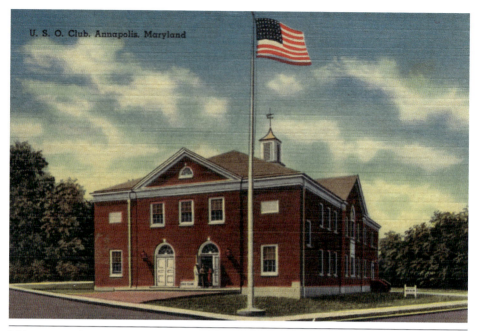

Military members who visited the United Service Organizations (USO) building at the corner of St. Marys and Compromise Streets in the 1940s might be surprised to know that the former Annapolis Recreation Center was renovated and now houses luxury condominiums at 99 Compromise. The building has balconies with views of the Annapolis Harbor area. There was an Annapolis USO for Black enlisted military members from the Naval Academy and Fort Meade during the war at the YMCA on Northwest Street.

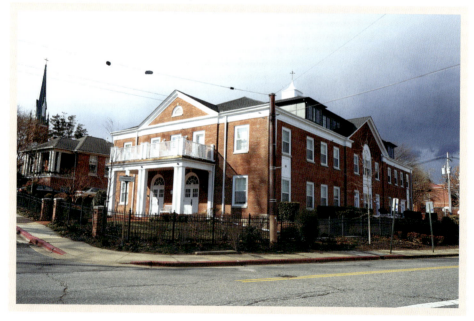

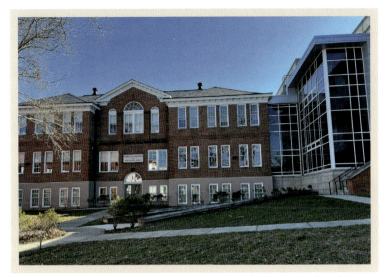

Until the construction of an elementary school that opened on Green Street in 1896, public schools in Anne Arundel County were one-room schoolhouses. Ninth- and tenth-grade classes were added to the elementary school in 1898, and the high school opened in 1907. Today's Annapolis Elementary School remains the oldest structure in continuous service as a school in the state of Maryland. It was fully renovated and modernized in 2015. Anne Arundel County schools were racially segregated until 1966.

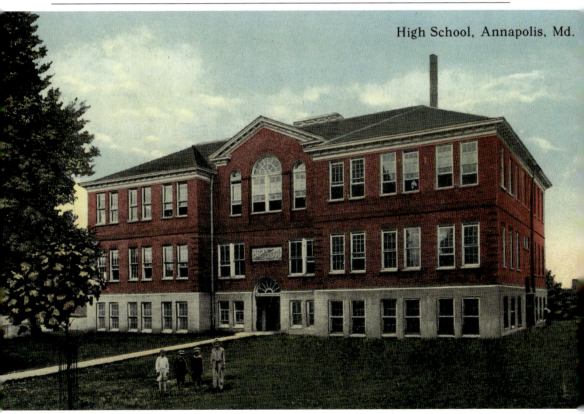

HISTORIC BUILDINGS

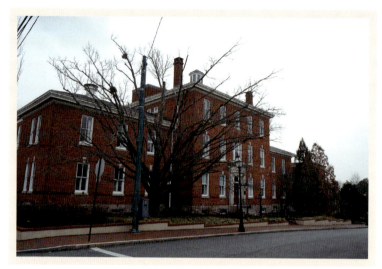

The earliest patients at the new Annapolis Emergency Hospital Association building on Franklin Street in 1910 suffered from a typhoid fever outbreak that struck the area. It was constructed on the site of the first hospital, built in 1902. The three-story building was significantly expanded and named the Anne Arundel General Hospital in 1949. Hospital services were moved to the Anne Arundel Medical Center outside of the historic district in 2001. The building today is part of Acton's Landing Condominiums.

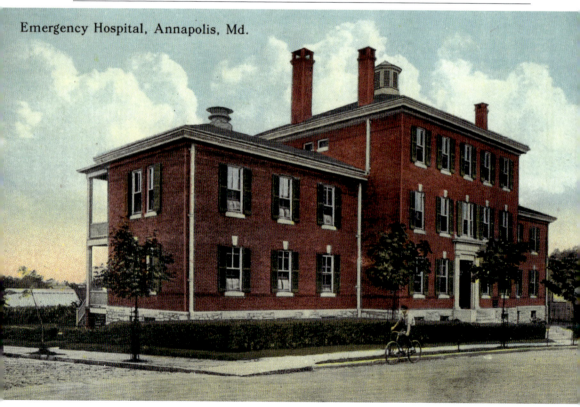

HISTORIC BUILDINGS

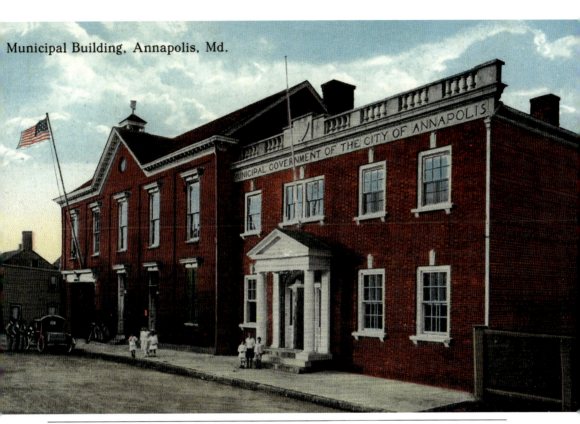

Municipal Building, Annapolis, Md.

Though located in the state's capital and county's seat, Annapolis city government maintains an independent presence. The offices of the mayor and city council are in the building at 160 Duke of Gloucester Street. The city has its own fire and police departments. Parts of the buildings have been used as an assembly room/ballroom, revenue office, library, and Independent Fire Company No. 2 with horse-drawn wagons. They were restored to look as they would have been during the 1800s.

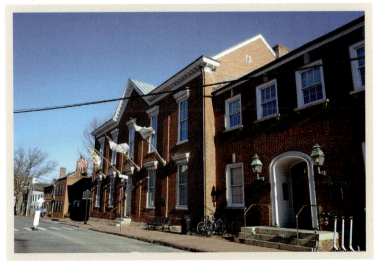

HISTORIC BUILDINGS

45

The Asbury United Methodist Church on West Street was built in 1888 where a wood-frame church was constructed in 1838 on land purchased by free African Americans in 1803. The congregation then included many slaves. It was named for Francis Asbury (1745–1816), the first Methodist Episcopal bishop in America, and remains an active church today. The sanctuary wing was added in 1977. Asbury is the rehearsal venue for the Annapolis Opera and hosts a winter concert.

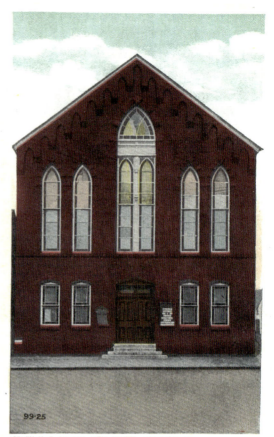

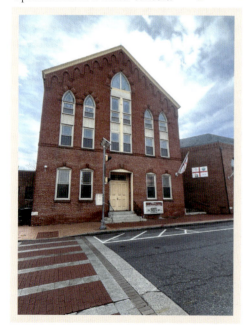

Historic Buildings

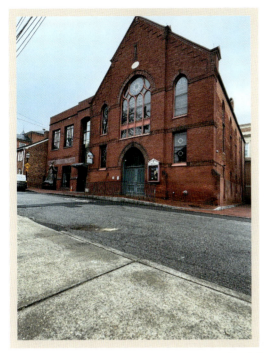

The Mount Moriah African Methodist Episcopal (AME) Church was completed in 1875 on Franklin Street on land where a frame church was built in 1850. A two-and-one-half-story addition was completed in 1984 when the Banneker-Douglas Museum for African American History and Culture opened as the state's official museum for these subjects. Lectures and other educational events are held there. Harriet Tubman's name was added to the museum in 2024.

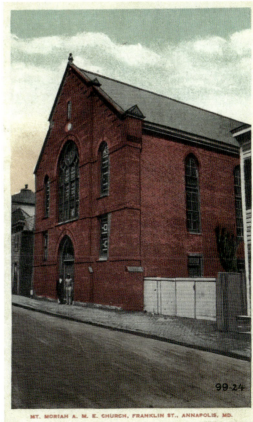

Historic Buildings

47

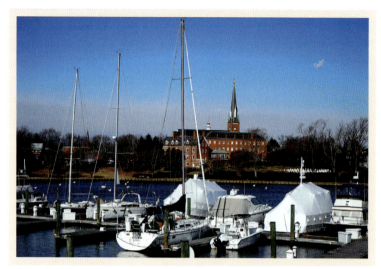

The view of the Carroll House and St. Mary's Church from the Eastport side of Spa Creek in 1905 and today would be familiar to the sender of this postcard, although the boats on the water certainly have changed from those kept in the boathouse at water's edge. The cemetery for Redemptorists in the Carroll Gardens was completed in 1948 with reburials of the prior deceased. The State House dome and St. Anne's steeple were not shown on the postcard.

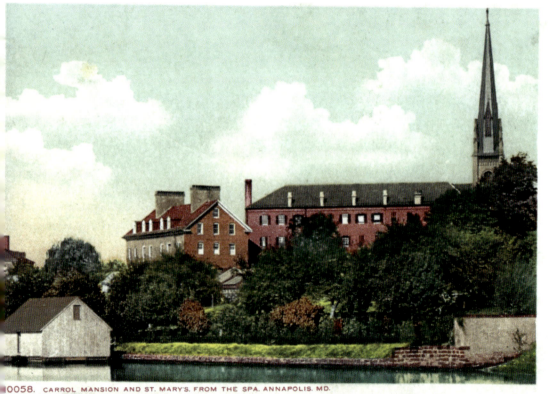

0058. CARROL MANSION AND ST. MARY'S FROM THE SPA. ANNAPOLIS. MD.

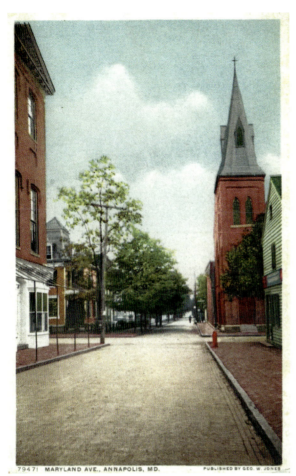

79471 MARYLAND AVE., ANNAPOLIS, MD. PUBLISHED BY GEO. W. JONES

The building on the left was built at the intersection of Maryland Avenue and Prince George Street in 1872 as a Masonic lodge and opera house with a hall that could seat up to 600 people. Masonic symbols remain on the building, which now has office and retail spaces. The church at the right was constructed in 1895–1897 as Calvary Methodist Chapel and later housed First Church of Christ Scientist. Today, it is Parish House Executive Suites.

HISTORIC BUILDINGS

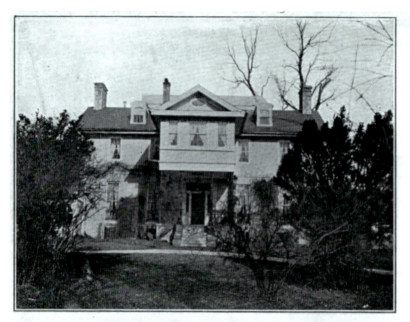

BIRTHPLACE OF REVERDY JOHNSON, NOW THE HOME OF HON. JOHN W. RANDALL.
Annapolis, Md.

The five-part-plan Bordley-Randall House was built in 1760 on a large property on State Circle by lawyer Stephen Bordley. Alexander Randall, an Annapolis businessman and politician, lived there in what became known as Randall Court. Reverdy Johnson, US senator, US attorney general, and minister to the United Kingdom, was born there in 1796. A misguided 1937 proposal to demolish the historic house for a state building met strong local opposition and was defeated. The house is a private residence.

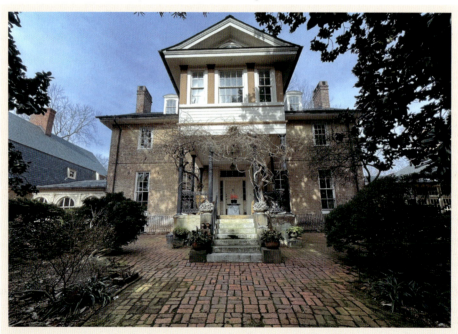

Historic Buildings

CHAPTER 4

Harbor and Market House

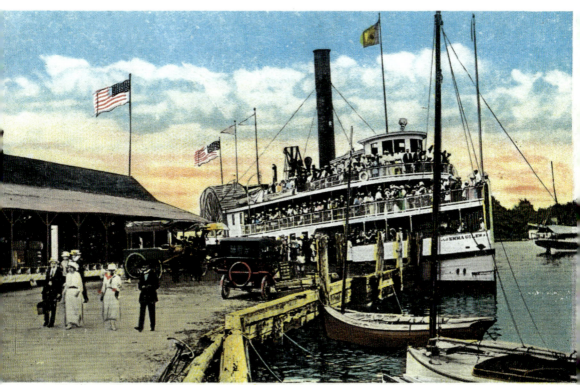

EMMA GILES AT TOLCHESTER WHARF, ANNAPOLIS, MD.

The Steamboat *Emma Giles* carried passengers on the Chesapeake Bay into the Annapolis Harbor into the 1930s. The City Dock area has been a center of nautical commerce and recreation for over 300 years. Ferry service for automobiles between the King George Street slip, and later Sandy Point, and the Eastern Shore continued until 1952 when the Bay Bridge opened.

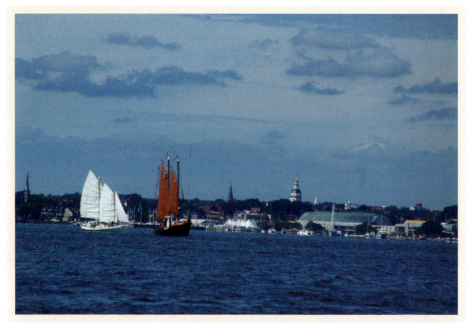

This 1930s view from a ferry crossing the bay from Matapeake on Kent Island shows how commercial the City Dock area was with oil storage tanks and wood at Johnson's Lumber Yard at the foot of King George Street. The Naval Academy took much of the property in the early 1940s, including private homes, businesses, and piers. It built Halsey Field House in the space in 1957. The harbor hosts many sailing events and two major international boat shows annually.

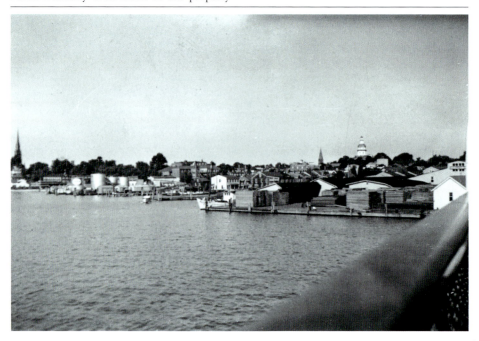

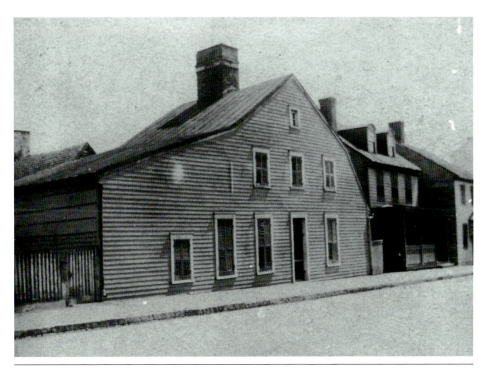

Constructed around 1740, the Sands House is one of the oldest surviving frame houses in Annapolis. Purchased by John and Ann Sands in 1771, it remained in the family for six generations until 2015. It was used as a tavern and residence and today is a private home on Prince George Street in the area once known as Hell Point, just steps from Annapolis Harbor. This photograph was taken around 1900. It is in the National Register of Historic Places.

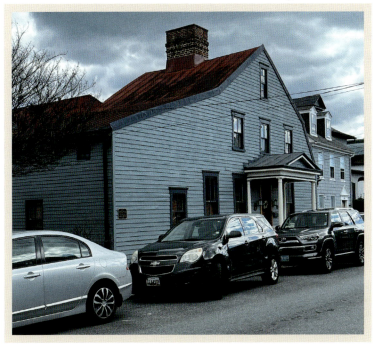

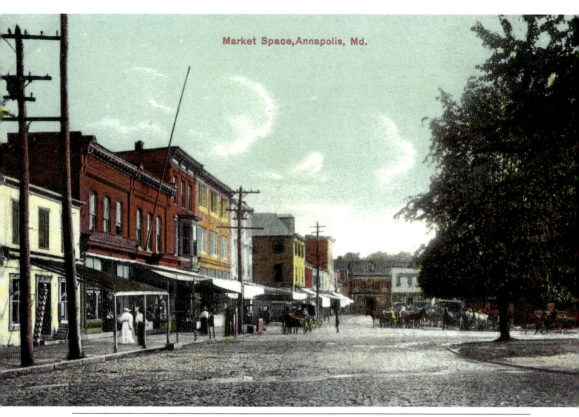

The barbershop and telephone poles at the Market Space in this 1910 view are gone, and horse-drawn delivery wagons have been replaced by cars and trucks, but many familiar buildings remain. A gas station with segregated bathrooms was built at the circle to the right in the 1930s and torn down in 1968. The circle area, constructed in the 1880s, was such a popular place for residents to walk their dogs that it earned the nickname "Dog Turd Park."

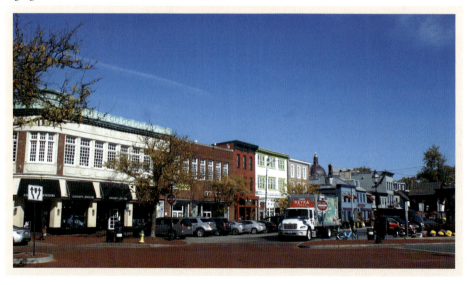

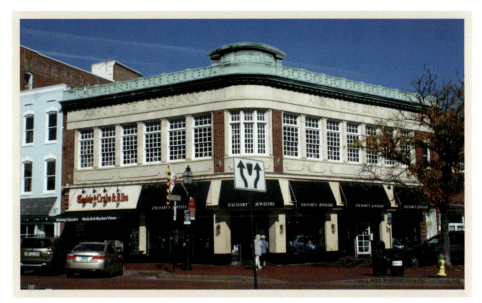

The Goodman building, at the bottom of Main Street, has been an important retail space since it was opened by Aaron Lee Goodman in 1909 as a clothing store. He also was the first president of Congregation Kneseth Israel after it was chartered in 1906. It remains a cornerstone of today's Market Space with shops and restaurants. A Banana Republic store occupied the space prior to Zachery Jewelers.

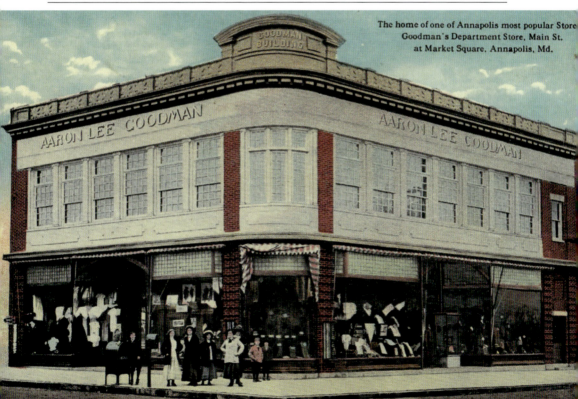

Harbor and Market House

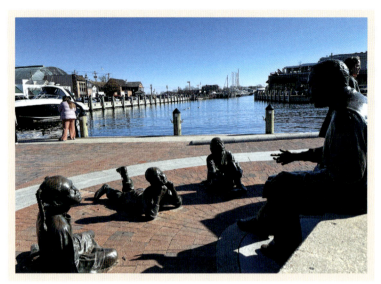

There once were so many Chesapeake Bay watermen oyster, fishing, and crabbing boats of various types, as well as interstate canal barges and freight boats, that a person could cross the harbor by jumping from deck to deck. Today, the statue of *Roots* author Alex Haley reading to children constructed in 1981 looks over a harbor visited by tourists and pleasure craft. Seafood processing houses have been replaced by restaurants and shops and US Naval Academy buildings.

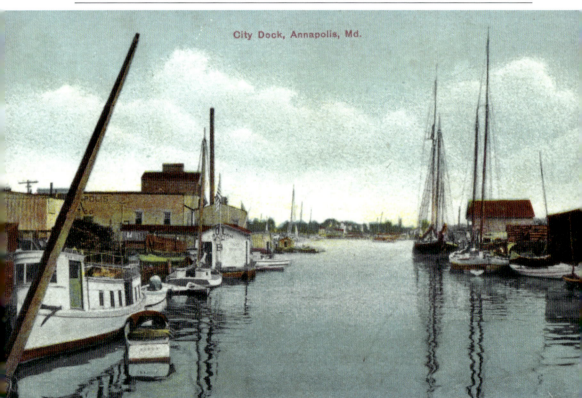

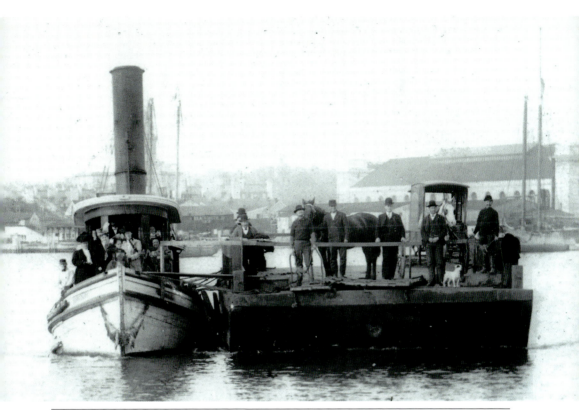

A ferry ran between the Annapolis dock and Eastport during the construction of a new steel bridge over Spa Creek, which opened in 1907. The new bridge replaced the wooden bridge built in 1868 and could better accommodate automobiles. Passengers complained that they sometimes had to wait for an hour for the ferry. Their other option was to travel three miles by land around Spa Creek. Water taxis now operate in the harbor.

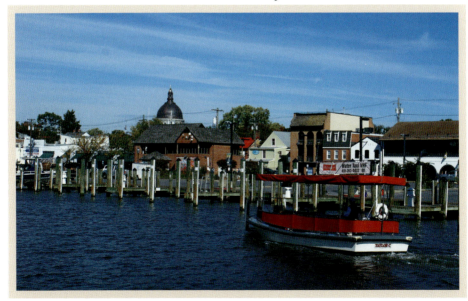

Harbor and Market House

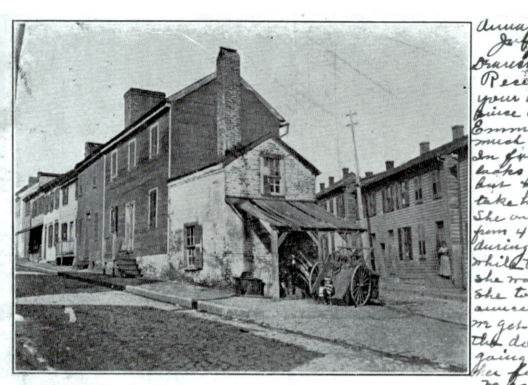

CATON'S BARBER SHOP, WHERE CATON SHAVED GEN. WASHINGTON IN 1783. Annapolis, Md.

Legend has it that Gen. George Washington got a haircut at Caton's barbershop where Fleet and Cornhill Streets meet before resigning his commission in 1783. A 1930s photograph shows the shop on the corner as W.L. Hutton Barber Shop. Once the homes of working-class people, including many African Americans, with jobs at City Dock and the Naval Academy, some houses on these streets that end at the harbor now sell for close to $1 million.

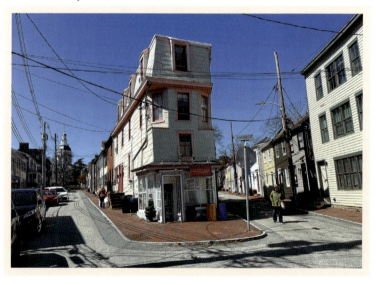

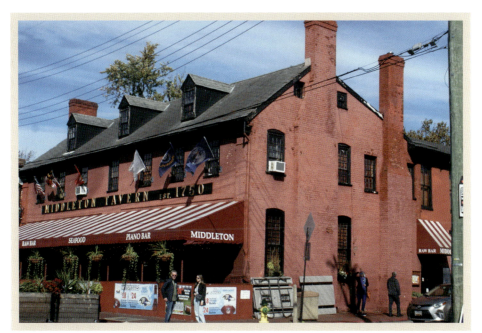

The 1750 date on the sign on today's Middletown Tavern reflects its beginnings as an "Inn for Seafaring Men" opened by Horatio Samuel Middleton. It eventually became a spot where "Annapolis Elite Would Meet to Eat" and discuss politics and current events. Photographs from over the years show it as a residence, Mandris' Confectionary store, restaurants, and retail stores. The building was restored following a fire in 1970. The building at left of the tavern's expanded porch is now McGarvey's.

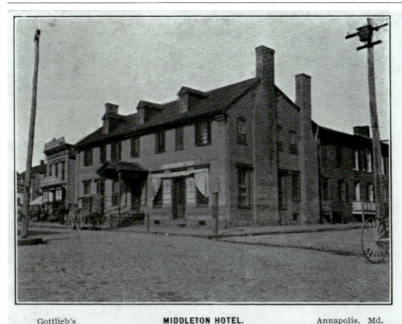

Gottlieb's Department Store. MIDDLETON HOTEL. Annapolis, Md.

HARBOR AND MARKET HOUSE

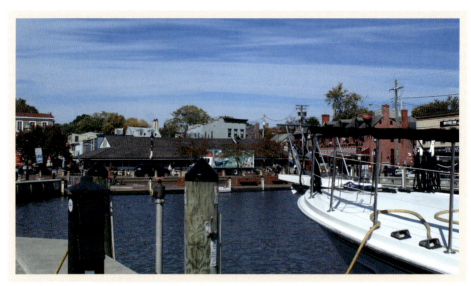

This 1917 view shows the fish market that stood in front of the Market House, built in 1858. Seafood buyers would meet watermen with fresh catches there for distribution throughout the area. Most of the buildings in the background still stand today. The fish house was taken down in 1940. The reference to the British officers regarded the first attempt by Parliament to establish an internal tax in the colonies. Such opposition led to its repeal in 1766.

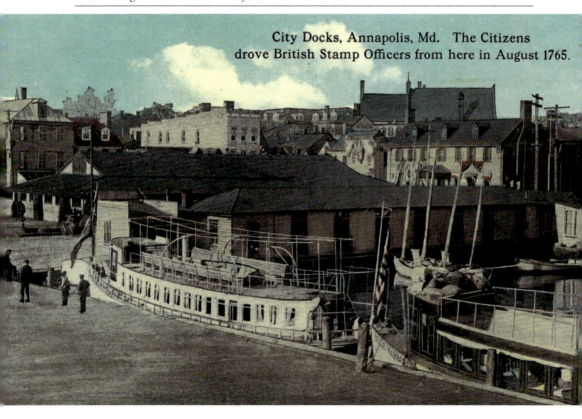

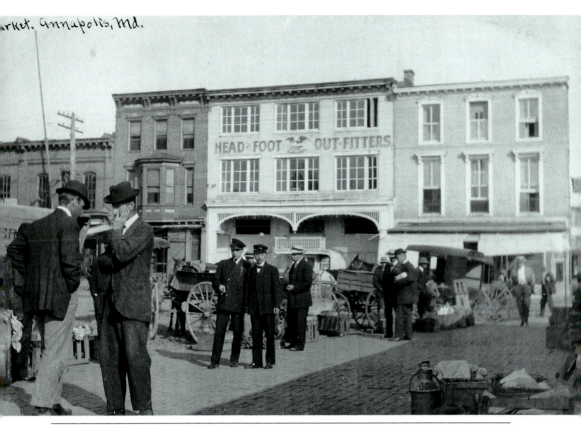

Hats for gentlemen were apparently required to conduct business in the Market House area in the early 1900s. The buildings that housed commercial businesses tied to the harbor and for residents still stand but are used for restaurants and specialty clothing, jewelry, and other retail purposes. Streetcars, buses, and wagons provided transportation to local hotels or the train station for further travel to Baltimore or Washington. The area is just a short walk for midshipmen from the Naval Academy.

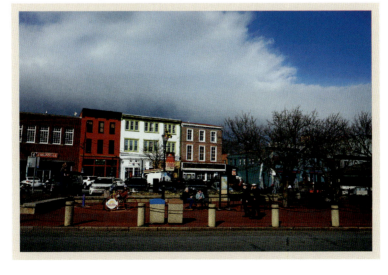

Harbor and Market House

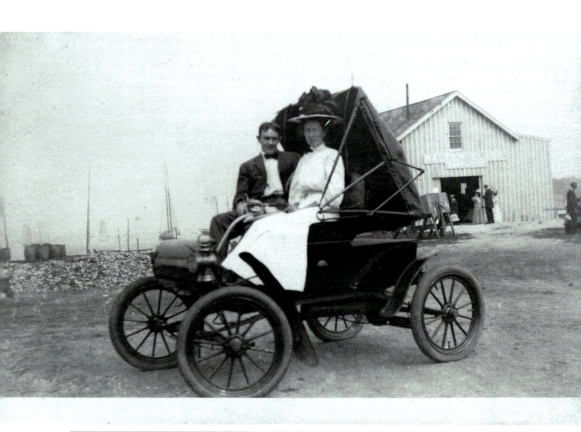

The automobile age had arrived in Annapolis by 1908, as shown in this photograph of Fred and Bess Bullard in their gasoline-powered, curved-dash Oldsmobile in front of the Walter Clark Oyster Packing plant at Compromise Street from Eastport at the City Dock. The oyster and other processing facilities that provided employment for many female and African American workers have been replaced with restaurants now serving seafood from around the world.

CHAPTER 5

A Walk about Town

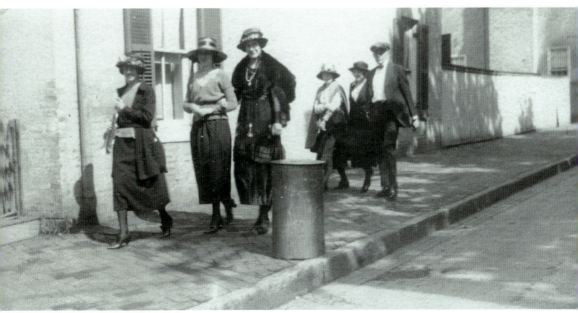

These nattily dressed pedestrians seem to enjoy walking down Duke of Gloucester Street near Conduit Street. Historic Annapolis is a classic "walking city" with historic buildings, restaurants, and shops in every direction. Information for self-guided tours or a variety of guided walking or water tours of Annapolis is available at the Annapolis Visitors Center on West Street at Church Circle.

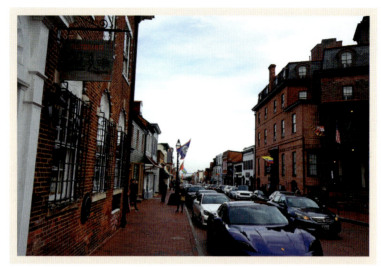

Main Street today shows the use of brick on the street and sidewalks to help maintain a historic atmosphere. Brick patterning on the ground plane differentiates pedestrian and vehicular flow and identifies historic zones. The 1908 view of Main Street shows a crowd perhaps gathered to examine one of the first automobiles to drive up the hill. The State House dome has been painted in different shades over the years, but the pattern on this card may have been added.

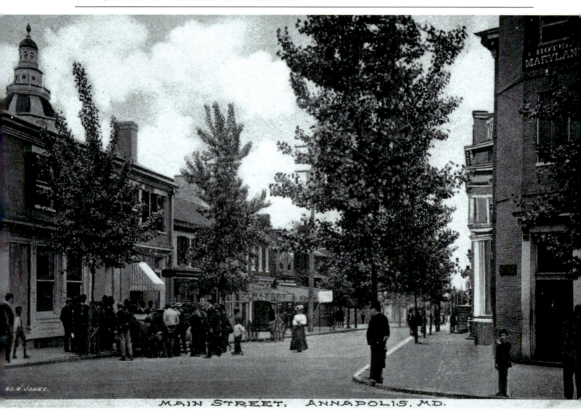

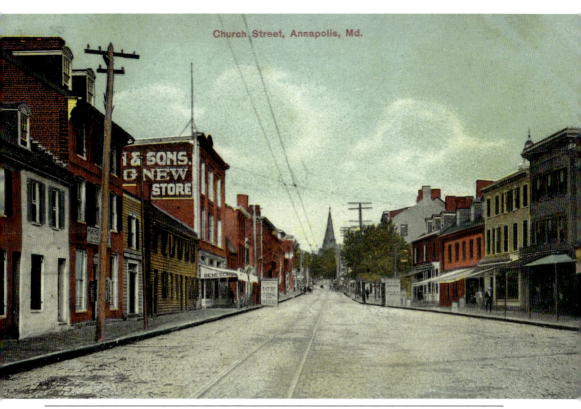

Originally called Church Street, Main Street once had two-way traffic. Families lived over their businesses. Telephone poles and railroad tracks are no longer found on Annapolis's busiest street, now full of specialty shops and restaurants. Some of the buildings date to the 18th century. The sign midway up the street advertises "Ice, Coal, and Wood." The painted sign was for The Great House of Isaac Benesh & Sons Store, which sold furniture. A pharmacy and offices now occupy that building.

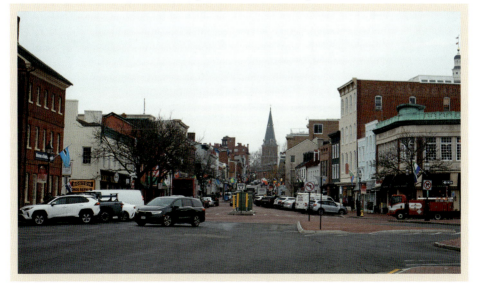

A WALK ABOUT TOWN

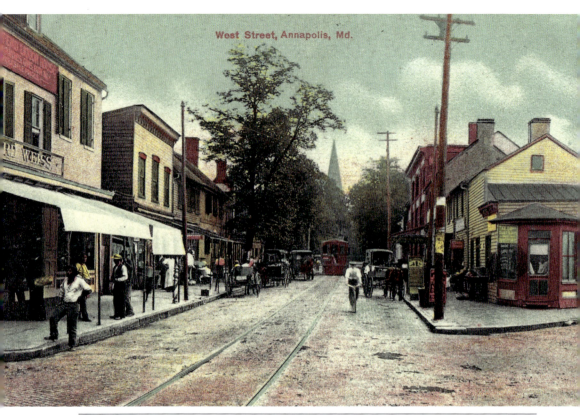

Edward Weiss operated "the Leading West End Liquor House" at 60 West and Calvert Streets in 1908. The large building there houses the Office of State Comptroller, the Maryland Chamber of Commerce, and a post office. Part of West Street was paved in 1900. Modes of transportation then included horse and buggy, trolley, bicycle, and a good pair of shoes. West Street from Calvert Street to Church Circle is closed off for First Sunday Art Festivals from May to November.

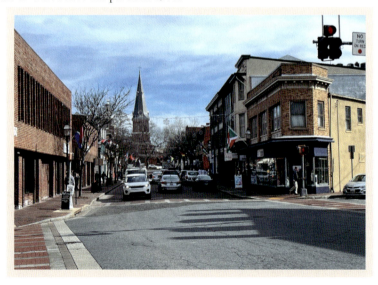

Trolley service from the Washington, Baltimore & Annapolis Railroad station at West and Calvert Streets began in 1908. From Church Circle, the route went down Main Street to Randall Street, past the Market Space and ferry dock, then from King George Street to College Avenue, past St. John's College, then back through Church Circle to the West Street station. WB&A trains from the Bladen Street station went to Baltimore and Washington. An intercity bus station was later located on West Street.

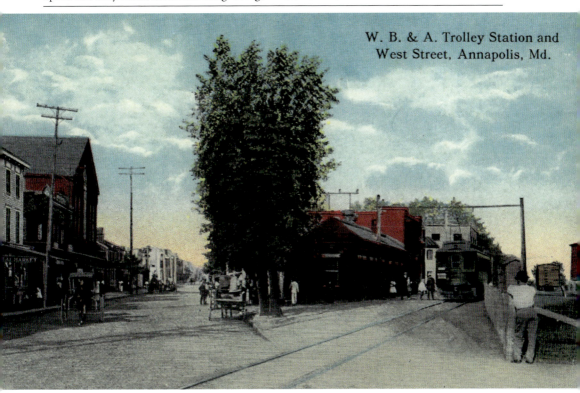

A WALK ABOUT TOWN

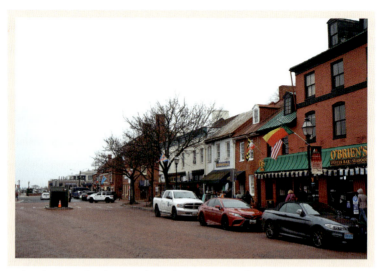

The sign at the photography shop on the right near today's O'Brien's restaurant reads, "Have your PHOTOGRAPH on a postal card." The large building at Main and Green Streets with the McEldin sign traces its roots to 1791 and, in this c. 1908 photograph, housed an antique furniture store owned by Moses Rodnick. Appropriately, today it is the home of the Historic Annapolis Museum. Partlett & Partlett Inc. sold coal, ice, and building materials at the bottom of Main Street.

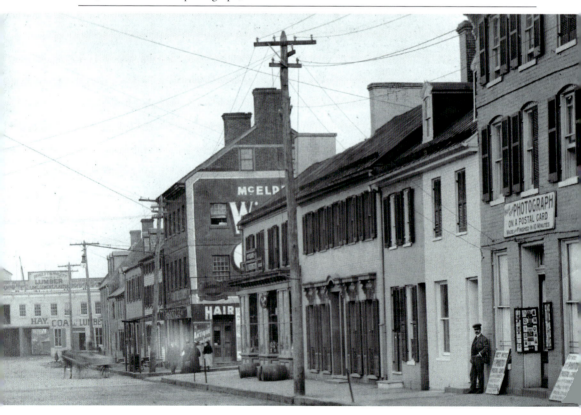

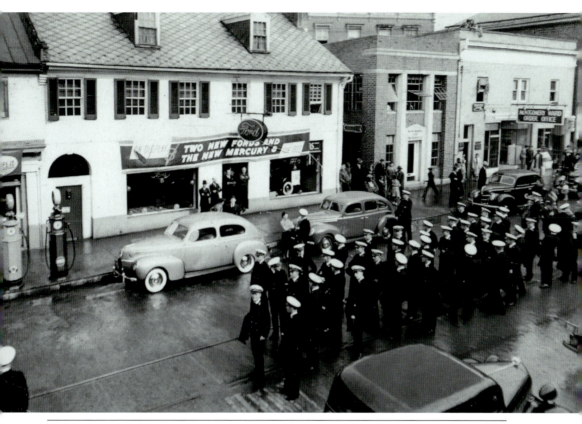

Midshipmen march past Western Auto with fuel pumps and a Ford dealership advertising the 1939 Mercury and Ford sedans on West Street on their way to the Washington, Baltimore & Annapolis Railroad station. Today, Herrmann Advertising and Design, the Annapolis Visitors Center, and the Christian Science Reading Room occupy those buildings. There is a plaque here that marks the location of the City Gate House and wooden fence from 1698–1790 to "keep out wandering cattle and men of ill fame."

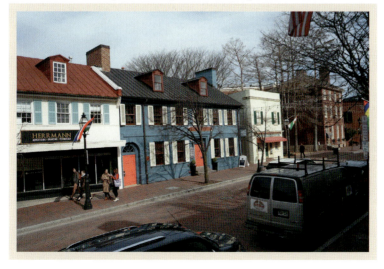

A Walk about Town

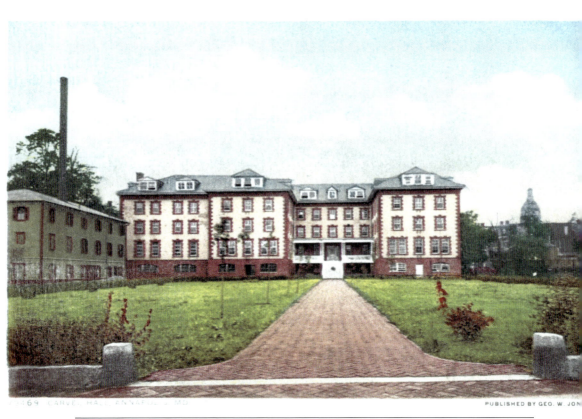

The Carvel Hall hotel was added to the rear of the historic William Paca House facing King George Street in 1901. It included two wings and a parking lot at its side. The hotel was closed in 1965, and it and the colonial Paca House were scheduled for demolition to build a motel. Anne St. Clair Wright and Historic Annapolis raised money to purchase the property and restore the house and gardens. They are open for tours and events.

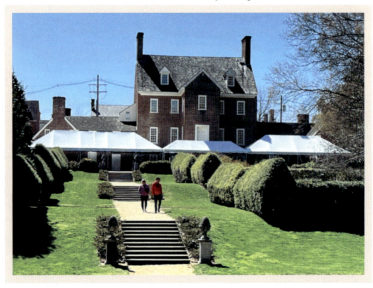

Prince George Street crosses Maryland Avenue as it connects College Avenue, earlier called Tabernacle Street, and Annapolis Harbor. It passes the William Paca and James Brice Houses. Perhaps ironically, St. John's College and the US Naval Academy, two historic institutions of higher learning with significantly different curricula, are at its opposite ends. This view toward the college from Maryland Ave shows the side of the old opera house and retail shops and homes from 1910 that still stand.

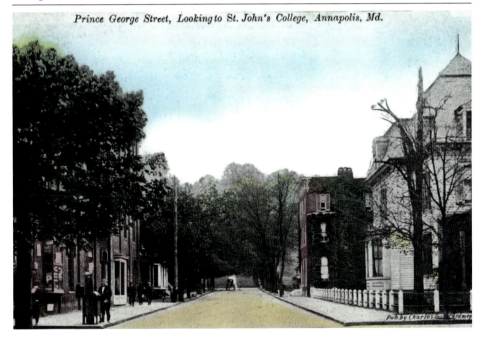

A WALK ABOUT TOWN

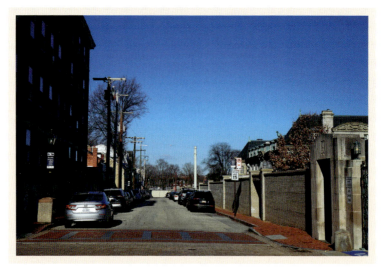

From its earliest days, Annapolis has faced the threat of fire to its people, businesses, and historic buildings. The first firefighters were local citizens who would relay water to the fire site in leather buckets. The horse and fire wagon shown rushing along the Naval Academy wall near the Maryland Avenue gate on Hanover Street would have come from the station on nearby East Street. The city received support from the Naval Academy midshipmen when serious fires broke out.

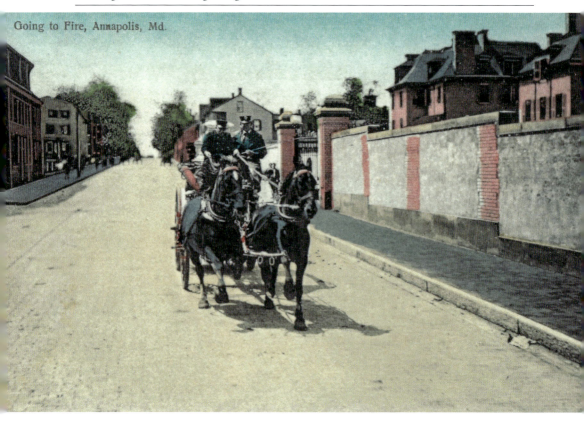

Going to Fire, Annapolis, Md.

A WALK ABOUT TOWN

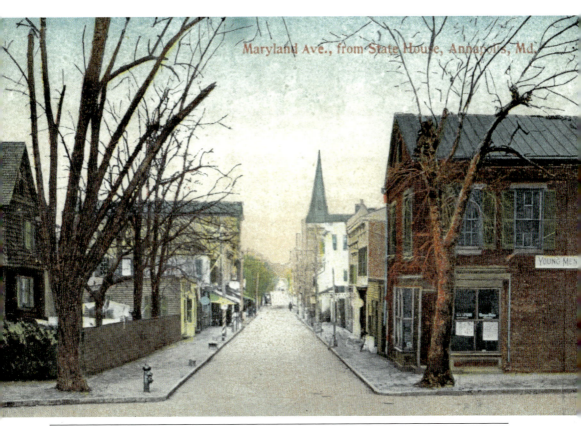

When Thomas Jefferson and James Madison rented a house on what is now Maryland Avenue, the historic street ran all the way to the water and was called North East Street. The building on the right was home to the YMCA in 1908. Generations of midshipmen would know the store as Johnson's on the Avenue until it closed in 2008. One of the oldest commercial streets in Maryland, it today has a variety of antique shops, bookstores, restaurants, and retail shops.

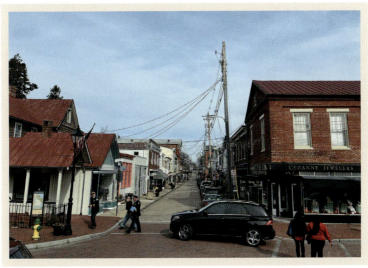

A Walk about Town

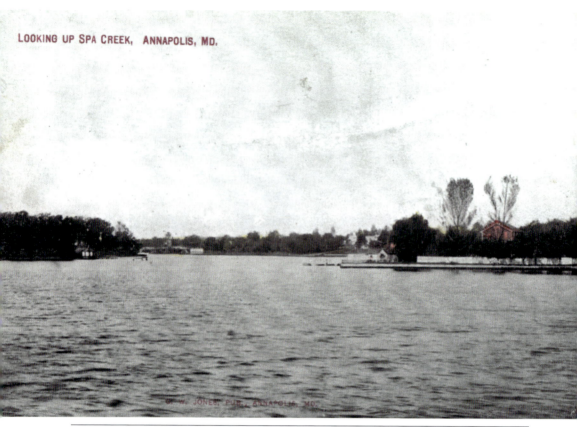

This early-1900s view of Spa Creek from the wooden bridge connecting Annapolis and Eastport was a bit more serene than that from today's drawbridge on the creek lined with expensive homes and pleasure boats. In the late 1880s, a railroad bridge built across the top of Spa Creek took passengers between Annapolis and Bay Ridge, where a hotel resort and ferry across the Chesapeake Bay to Claiborne were located. Note the model sailboats racing on Spa Creek.

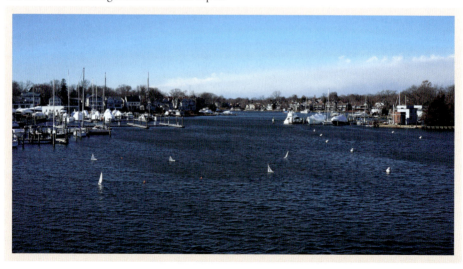

The latter 1800s saw the development of the area southwest of the historic district. The streets running to Spa Creek from Shipwright, Cathedral, Market, and Franklin Streets were home to many of Annapolis's merchants and working people. This house on Market Street at Acton Cove on Spa Creek was built in 1903 and is one of many classic homes that can be seen in the area where the earliest port of entry into Annapolis was located.

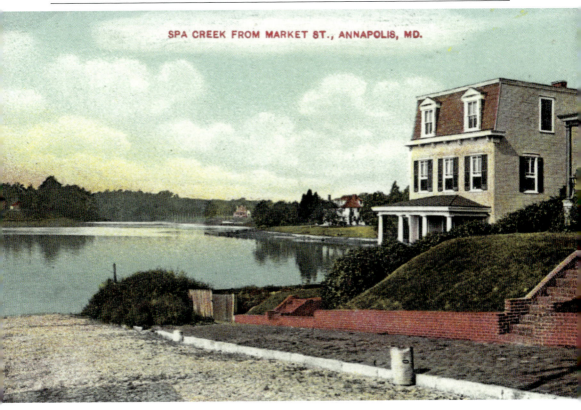

A Walk about Town

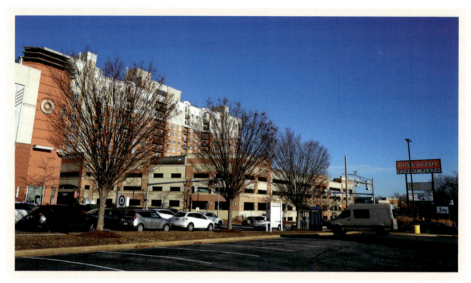

The American horse racing industry was born in Maryland, which still hosts the Pimlico leg of the Triple Crown. Race enthusiasts took their own carriages to watch the trotter races in the Parole section of Annapolis, which had housed a prisoner-of-war exchange camp for paroled Union soldiers who agreed to not rejoin battle. There were similar camps in the South. The old racetrack is now a major shopping and high-rise residential area. Parole Plaza opened in 1962.

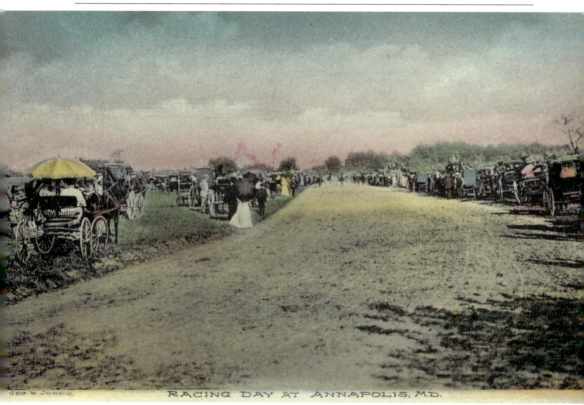

CHAPTER 6

St. John's College

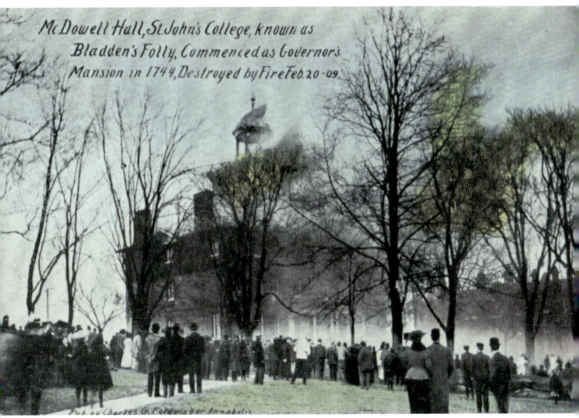

A devastating fire broke out in McDowell Hall on St. John's campus on February 20, 1909. Students, citizens, US Naval Academy midshipmen, and local firefighters responded. Students were credited with quickly organizing rescue teams that saved many historical documents and pictures. The 1744 building was reconstructed rather than razed and reopened in 1910.

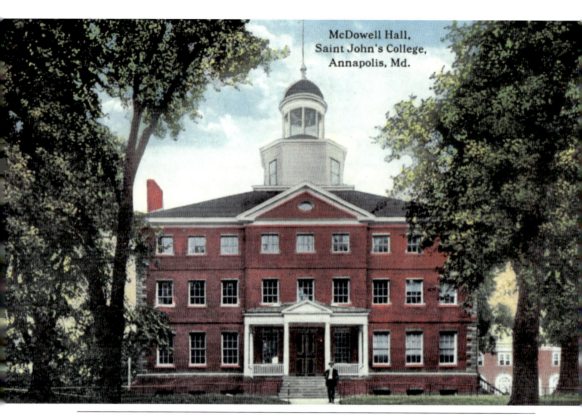

McDowell Hall was the first building on the St. John's campus and traces its roots to 1744, when then-Governor Thomas Bladen began building a future Governor's Palace. The building was not completed until 1789 and became known as Bladen's Folly. Maryland chartered St. John's College in 1784, merging it with King William's School, which opened in 1696. Its classrooms, lecture halls, and cupula had a $5-million renovation in 2017–2018. The postcard shows McDowell Hall before the 1909 fire.

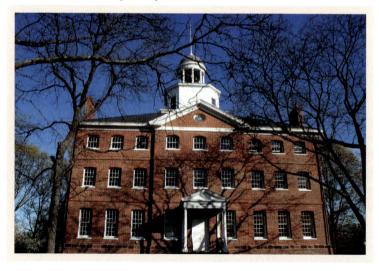

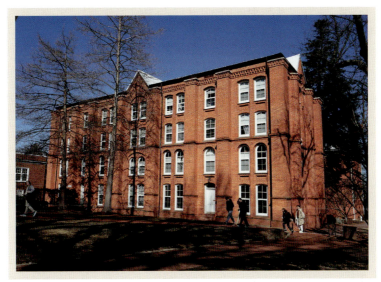

Pinkney Hall was constructed in 1857 but was not occupied until after the Civil War. It was named for William Pinkney (1764–1822), who served in Pres. James Madison's administration and is believed to have attended St. John's College's predecessor, King William's School, which was founded in 1696. Note the student in military garb, as St. John's had adopted compulsory military training in 1884. The public safety office and single-occupant rooms for upperclassmen are in the coed dorm.

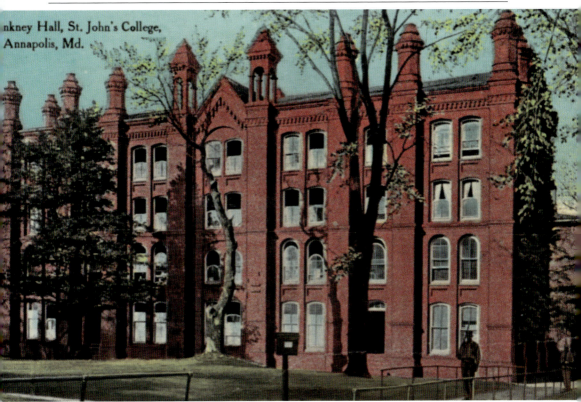

St. John's College

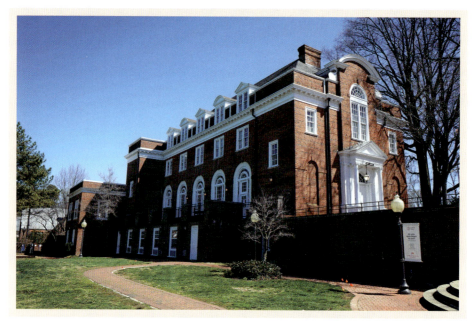

Constructed in 1903 as a dining facility, Senior Hall was designed by architect T. Henry Randall and renamed Randall Hall in honor of his brother, John Wirt Randall, in 1912. It is today a dining hall, student health and wellness center, and on two floors, a residence primarily for first-year female students. The building was renamed Fielding-Rumore Hall in 2023 for two major donors and supporters. Efforts of the US Navy to acquire the college campus in 1945 were unsuccessful.

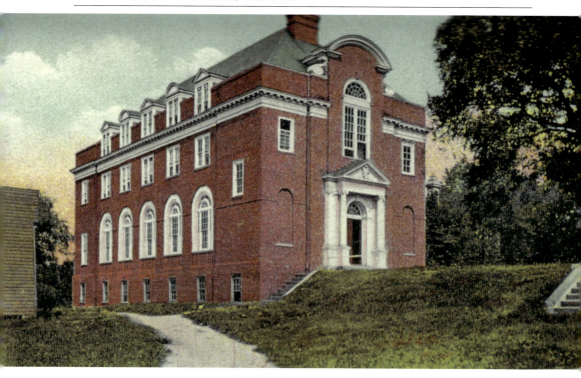

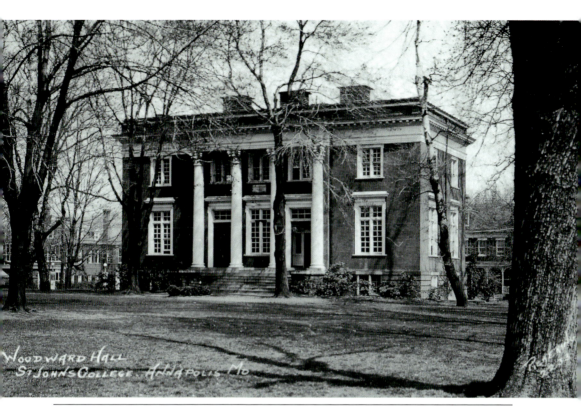

Built in 1899 to serve as the St. John's College library, Woodward Hall also housed the biological, chemical, and physical laboratories and an armory during the military school years. It has been renovated several times and is today called Woodward Hall/Barr-Buchanan Center, home to Graduate Institute offices and classrooms, including the Hartle Room and King William Room. The postcard photograph was taken by Edgar Pickering, who had a shop on Maryland Avenue and was the St. John's College yearbook photographer.

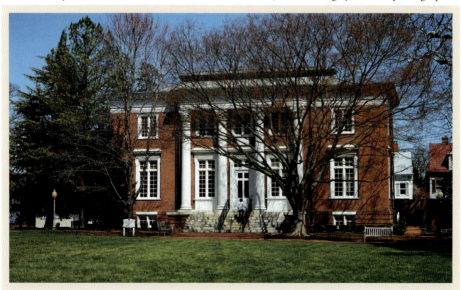

ST. JOHN'S COLLEGE

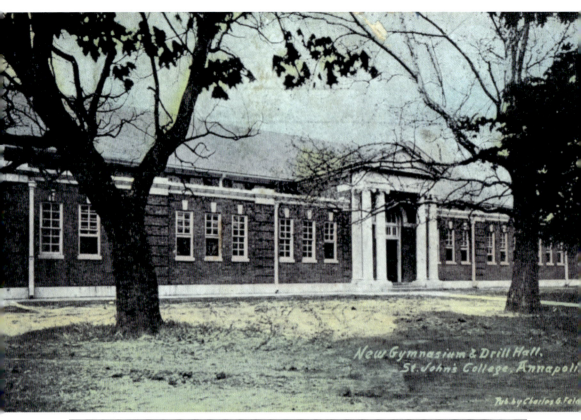

The "New Gymnasium & Drill Hall" on this postcard was built in 1910. St. John's was named one of the top five military colleges in the country by the War Department in 1905, but military training was abolished by 1923. The building is named for Dr. James Iglehart, an 1872 graduate who was president of the US National Lacrosse Association in 1881. The building is used for a variety of sports and recreation today and has an elevated wooden track.

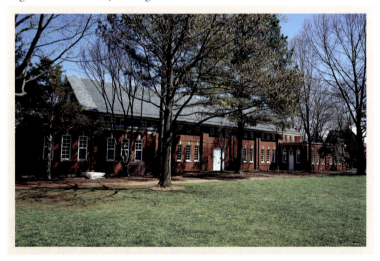

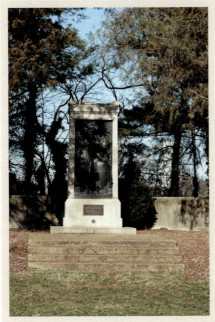

Pres. William Howard Taft dedicated the French Soldiers and Sailors Monument in 1911 to honor those who died in Annapolis in September 1781 during their march to fight the British at Yorktown. The unknown soldiers and sailors who were buried along College Creek likely died from disease. There is a World War I memorial at the front of the campus to remember the 424 alumni who served in World War I and the 24 who died.

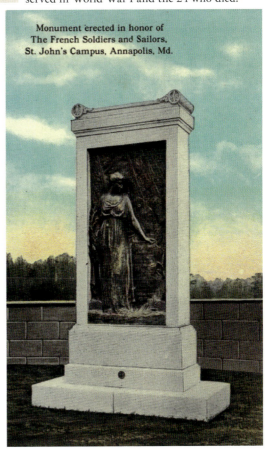

These women joined others who have gathered at the Liberty Tree, including colonialists during the Revolutionary War. The tulip poplar was almost 600 years old when destroyed by Hurricane Floyd in 1999. The tree's seedlings have been planted throughout Maryland and on Capitol Hill in Washington. A piece of the tree is displayed at the Museum of the American Revolution in Philadelphia. This tulip poplar was planted at the site between Pinkney Hall and Chase-Stone House in 2007.

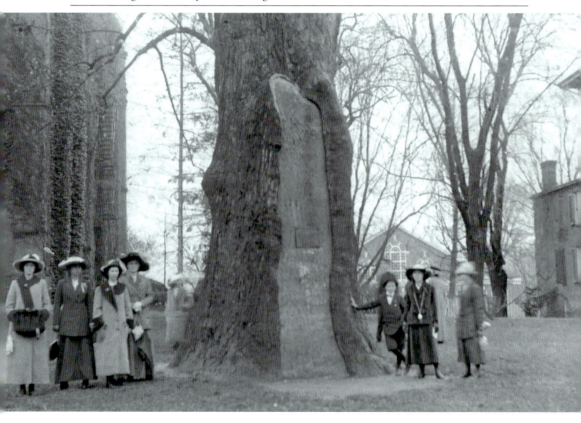

CHAPTER 7

US Naval Academy

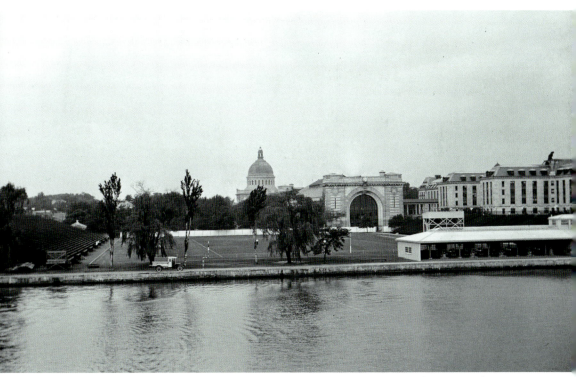

This 1930s view of the US Naval Academy shows Thompson Field, the Naval Chapel, Dahlgren Hall, Bancroft Hall, and gun sheds along the water. The Naval Academy was founded in 1845. The Brigade relocated to Newport, Rhode Island, during the Civil War as Annapolis had strong Southern sympathies. The grounds were used as an Army post and hospital. It is an essential part of Annapolis's history. Many local families host midshipmen in their homes and develop lifelong friendships.

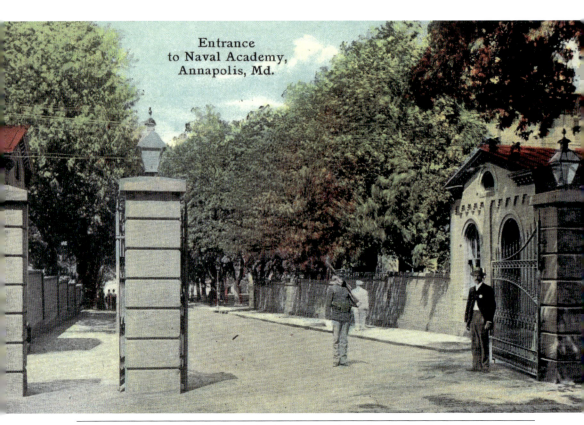

The main gate to the US Naval Academy was where Maryland Avenue crosses Hanover Street for much of the academy's history. After the 9/11 attacks, the only gate open to the public is from King George Street near City Dock, where visitors are screened by military guards and outside vehicle use is severely restricted. The two buildings just inside the gate, built in 1876, predate the early-1900s academy modernization. This gate can be used to exit the academy.

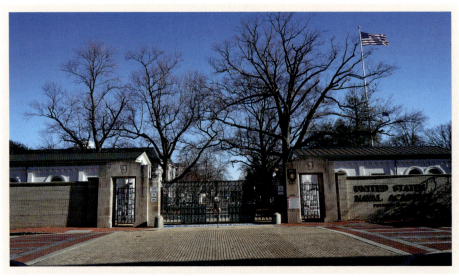

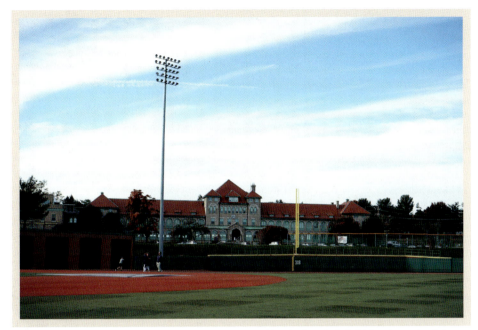

Drills on the field in front of the Marine Barracks Building, constructed in 1903, have changed since students in the US Marines School of Application gathered there in the early 1900s. It is now used by the USNA baseball team at Bishop Stadium on Lawrence Field. The baseball field has hosted exhibition games between the USNA and major-league teams. The building also was used as the Naval Postgraduate School. Halligan Hall currently houses the USNA Public Works Department.

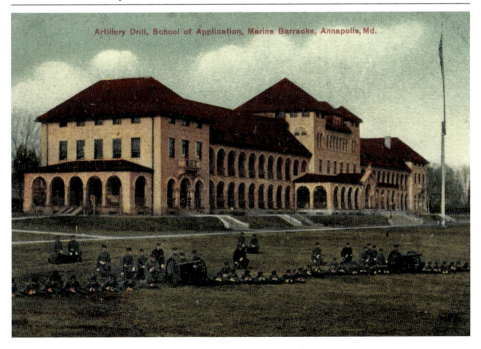

US NAVAL ACADEMY

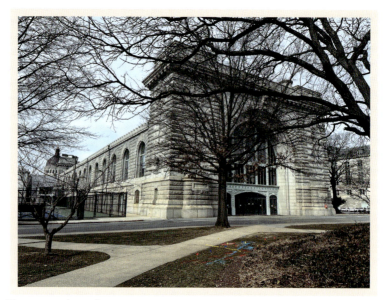

Designed by Ernest Flagg, the Armory opened in 1903 and was soon named Dahlgren Hall in honor of Adm. John A. Dahlgren, known as "the father of naval ordnance." It has been one of the most versatile academy buildings, having been used for indoor drills and ceremonies including memorial ceremonies for John Paul Jones, at which Pres. Theodore Roosevelt spoke, dances, athletic events, and until 1957, graduations. Historical displays, including a Wright Brothers B-1 replica airplane, are open to the public.

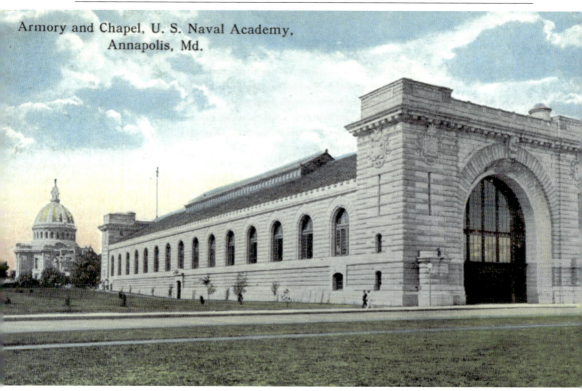

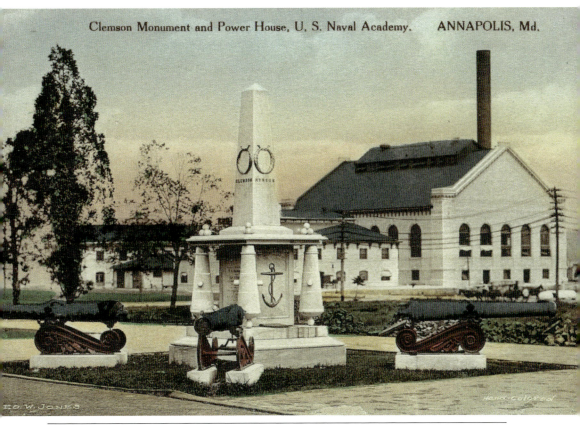

Clemson Monument and Power House, U. S. Naval Academy. ANNAPOLIS, Md.

The marble Mexican-American War (1846–1948) monument on Stribling Walk was dedicated to the memory of four fallen passed midshipmen (pre–Naval Academy future commissioned officers) in 1848. It also is called the Clemson Monument after Henry Clemson, who was one of the fallen. The others were John Pillsbury, John Hynson, and Thomas Shubrick. The four Spanish cannons were captured during the war. The old power plant area is now covered with academic buildings, including Michelson Hall at the right.

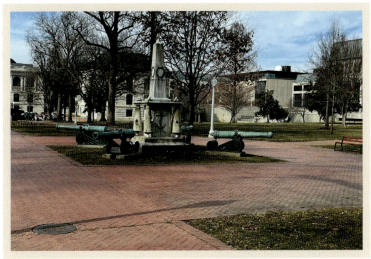

US NAVAL ACADEMY　　　　　　　　　　　　　　　　　　89

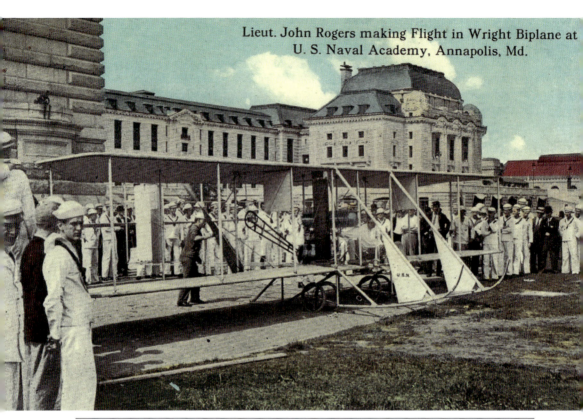

Lieut. John Rogers making Flight in Wright Biplane at U. S. Naval Academy, Annapolis, Md.

The US Naval Academy, often called "the Yard," has been involved in the evolution of military flight from the biplane era of Lt. John Rogers at Farragut Field on the "water side" of Bancroft Hall to manned space flights. As of 2023, over 50 USNA graduates have become astronauts. The US Navy Blue Angels, many piloted by USNA graduates, perform at graduation ceremonies every May. This area today is covered by laboratories, classrooms, and student services.

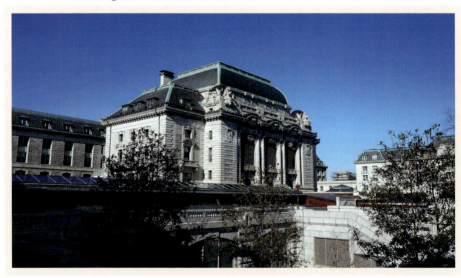

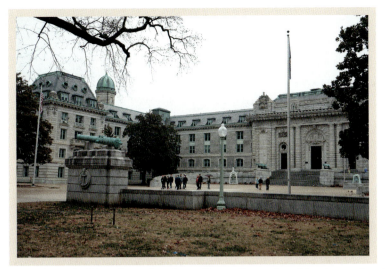

Bancroft Hall, also called "Mother B," is the largest academic dormitory in the world. First opened to students in 1904, it is today, after many additions, home to over 4,400 young men and women. The building includes a dining hall and almost five miles of corridors. George Bancroft, a historian and author, was secretary of the Navy and instrumental in establishing the Naval Academy in 1845. This "landside" view from Tecumseh Court is the main entrance to Bancroft Hall.

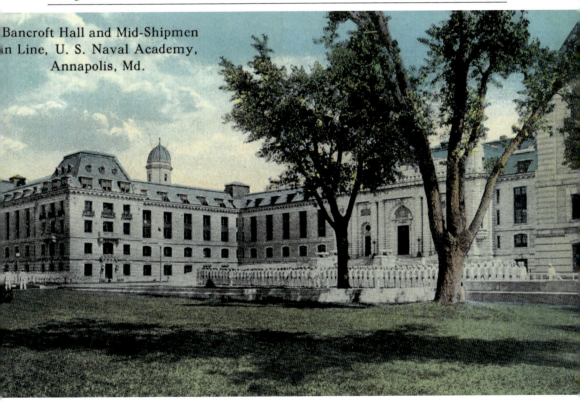

Bancroft Hall and Mid-Shipmen in Line, U. S. Naval Academy, Annapolis, Md.

US NAVAL ACADEMY

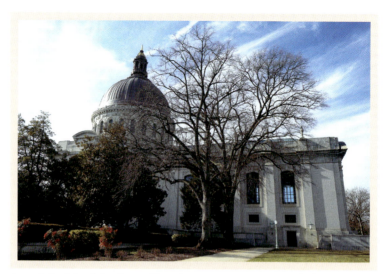

Construction of the Naval Academy Chapel, designed by Ernest Flagg, began in 1904, with its dedication in 1909. It includes the crypt of John Paul Jones. The nave was added in 1939. The original terra-cotta dome was replaced in 1928 with a copper one, which received new copper in 2020. Catholic Mass is said at 9:00 a.m., with Protestant services at 11:00 a.m. on Sundays. There are academy religious facilities for Jewish and Muslim students. Religious attendance is not required.

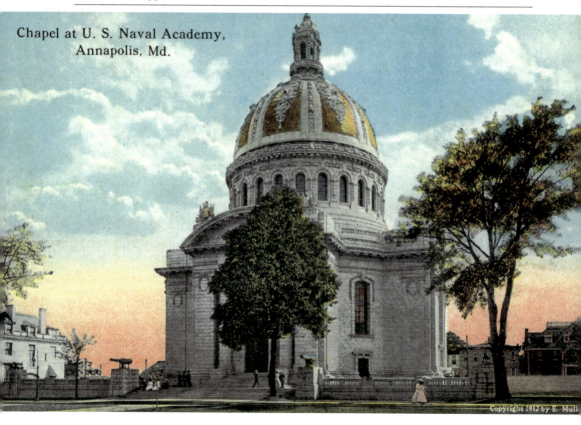

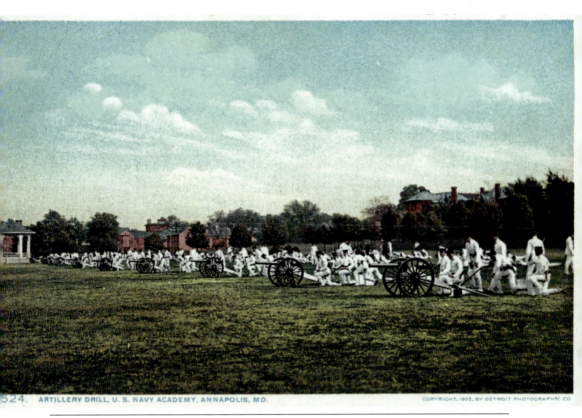

One of the busiest places on the academy grounds is Worden Field, where drills, parades, athletic events, and marches are held. It is named for Adm. John Worden, captain of the ironclad *Monitor* and a USNA superintendent. The bandstand in front of Upshur Row during a skirmish drill on this early-1900s postcard is like the one with the view of Alumni Hall, which opened in 1991 and hosts larger events, including sports, entertainment, and public lectures.

US NAVAL ACADEMY

93

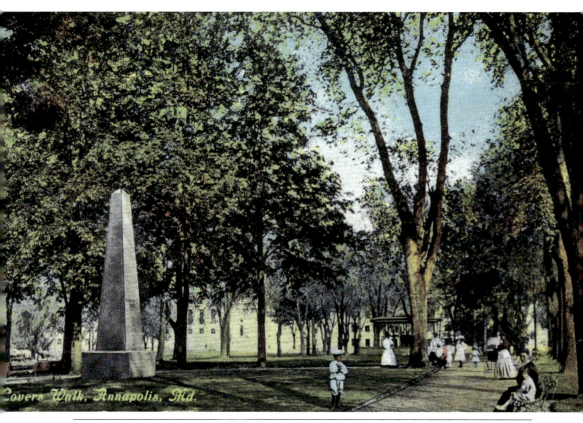

"Lovers Walk" from over 100 years ago looks quite similar today. One addition in 2022 was the ship's bell from the SS *Central* "Ship of Gold," which sank off North Carolina in 1857. Comdr. William Lewis Herndon went down with the ship but is credited with saving 152 lives. A monument to him was erected in 1860. Tradition has "plebes" climbing the monument covered with vegetable oil to remove a "dixie cup" hat marking the end of their first year.

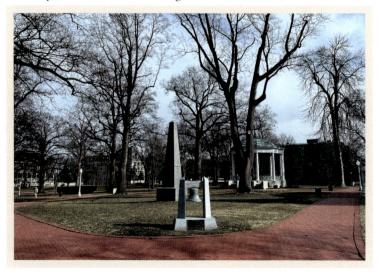

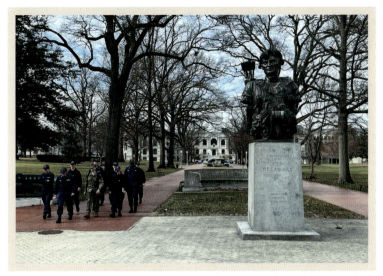

Stribling Walk from Bancroft Hall to Mahan Hall and other academic buildings takes midshipmen and visitors past Tamanend, better known as Tecumseh. A new nickname, "Selfie Supreme," could be added for the statue that was the figurehead for the USS *Delaware*, which sank during the Civil War. A bronze cast of the figurehead was made in 1930 and placed at its present location. Adm. Cornelius Stribling was a USNA superintendent. Temporary World War I barracks are on the postcard's right.

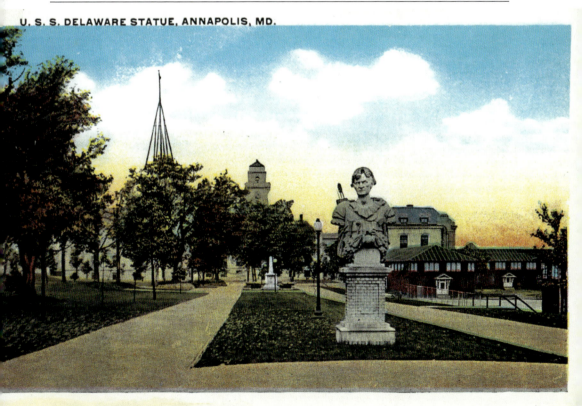

US NAVAL ACADEMY

Discover Thousands of Local History Books Featuring Millions of Vintage Images

Arcadia Publishing, the leading local history publisher in the United States, is committed to making history accessible and meaningful through publishing books that celebrate and preserve the heritage of America's people and places.

Find more books like this at
www.arcadiapublishing.com

Search for your hometown history, your old stomping grounds, and even your favorite sports team.

Consistent with our mission to preserve history on a local level, this book was printed in South Carolina on American-made paper and manufactured entirely in the United States. Products carrying the accredited Forest Stewardship Council (FSC) label are printed on 100 percent FSC-certified paper.